# BELIEVING IS SEEING

 Penguin Books

# BELIEVING IS SEEING

Creating the Culture of Art

# Mary Anne Staniszewski

*To my mother and father,*
*Anna and Herbert Staniszewski*

PENGUIN BOOKS
Published by the Penguin Group
Penguin Books USA Inc., 375 Hudson Street,
New York, New York 10014, U.S.A.
Penguin Books Ltd, 27 Wrights Lane,
London W8 5TZ, England
Penguin Books Australia Ltd, Ringwood,
Victoria, Australia
Penguin Books Canada Ltd, 10 Alcorn Avenue,
Toronto, Ontario, Canada M4V 3B2
Penguin Books (N. Z.) Ltd, 182-190 Wairau Road,
Auckland 10, New Zealand

Penguin Books, Ltd, Registered Offices:
Harmondsworth, Middlesex, England

First published in Penguin Books 1995

10 9 8 7 6 5 4 3 2

Copyright © Mary Anne Staniszewski, 1995
All rights reserved

Illustration credits appear on pages 309–310.

LIBRARY OF CONGRESS CATALOGING IN PUBLICATION DATA
Staniszewski, Mary Anne.
Believing is seeing: creating the culture of art/Mary Anne Staniszewski.
p.    cm.
Includes bibliographical references.
ISBN 0 14 01.6824 9
1. Masterpiece, Artistic.    2. Creation (Literary, artistic, etc.)
I. Title.
N72.5.S72    1995
700—dc20        94–1449

Printed in the United States of America
Set in Transitional and Avant Garde
Design conception by Mary Anne Staniszewski
Designed by Cheryl Cipriani

# Acknowledgments

I would like to thank in particular the following individuals at Penguin USA: my editor, Dawn Seferian, who made the book possible; Will Gillham; Paul Buckley, for his help with the cover; and especially Michael Hardart, for his daily assistance on all aspects of this publication. To my agent, Cynthia Cannell, of Janklow & Nesbit Associates, I owe many thanks for her tenacity, optimism, intelligence, and her faith in my work and in this book. Christopher Phillips, more than any other individual, assisted me with the manuscript and the picture research, and I want to thank him for his wisdom and friendship. Special thanks to Allan Schwartzman, who helped set the book in motion, read the manuscript, and contributed invaluable advice and friendship throughout the project. I also wish to acknowledge the counsel of my friend and colleague the late Paul Taylor, who read the first draft.

There are many individuals who assisted me with aspects of the manuscript and picture research: Douglas Blau, Nora Fish, Duncan Kennedy, Baruch Kirschenbaum, Claude Le Brenne, Sarah Lowe, Bonnie MacDonald, Paul McGinniss and Chris Ursitti of Walker, Ursitti & McGinnis, Richard Milner, Amruta Slee, Debbie Taylor, and Annette Weir of Art Resource. Joseph Kosuth and Allan McCollum made special provisions for their reproductions. A number of individuals contributed to the cover: the photographer Scott Roper and "the models," Shawn Jones, Frank Kitchens, Barbara D. Lee, Iris Libby, Mildred Schneider, and Mitchie Takeuchi. Babara Kruger generously

lent her piece. Jeanette Ingherman and Papo Colo permitted us to use the galleries of Exit Art.

There are also individuals whose assistance I sought throughout my work on the book but whose support went far beyond professional advice. Special thanks to Julie Mars, Ellen Silverstein, Jill Sussman, and Mimi Thompson. In addition, the following friends supported me in a variety of ways while I was working on the book: Julia Bondi, Heidi B. Fleiss, Iris Libby, Wanda Lopez, Scott Powers, Diane Dinacola-Powers, and Lisa Waters. Although I've dedicated this book to my mother and father, I also want to thank them for their wisdom, inspiration, and patience. Many thanks to my sister, Claudia Staniszewski, my brother and sister-in-law, Herbert and Kathy Staniszewski, my niece, Anna, and of course, Mary Basile, my dear Aunt Mary.

# Contents

*Instructions for Use* . . . . . . . . . . ix

What Is Art? . . . . . . . . . . . 1

Art and the Modern Subject . . . . . . . 101

The Term "Art" . . . . . . . . . . . 111

Aesthetics: The Theory of Art . . . . . 119

The Privilege: Creating Art . . . . . . 125

The Academy . . . . . . . . . . 161

The Museum . . . . . . . . . . 171

The Discipline: Art History and
      The Development of Modernism . . . 181

The Avant-Garde, Popular Culture, and the
      Creation of the Mass Media . . . . 199

Art and Culture Today . . . . . . . . 255

*Selected Bibliography* . . . . . . . . 303
*Picture Credits* . . . . . . . . . . 309

# Instructions for Use

I began working on this book, in a sense, twelve years ago, when I was confronted with the task of teaching "The History of World Art." I decided to restructure the standard lectures in order to make this anachronistic college course more intellectually valid. The ideas for this book really fell into place when I began teaching—primarily to graduate students and seniors—contemporary art, culture, and critical theory at the Rhode Island School of Design in 1985. I devised preliminary lectures that were intended to efficiently dispel much of the outdated mythology regarding art, modern subjectivity, and culture and that were meant to facilitate the students' approaching their field from a relatively sophisticated perspective. When I finally decided to turn my lectures into a book some six years ago, I took into account many of the questions artists, dealers, and art professionals had often asked me regarding aspects of art history and theory, and I also considered the discussions that I have had with individuals outside the field about the history of art.

As I see it, this book has a number of uses:

(1) It is meant to be a *supplement* to the canonical texts that shape art and humanities course curriculum. I am not, however, suggesting getting rid of our culture's collective aesthetic memory. In fact, I have gone to great lengths to use the most powerful and famous images of what has been called our "museum without walls." I conceive this book as a means to reframe this massive institutionalized

canon in order to lay a new groundwork and to raise important questions.

(2) I would hope that individuals who are informed about modern and contemporary art and culture but who are not familiar with certain aspects of modern and contemporary art history and theory would find this book a helpful overview.

(3) I also hope that individuals who are interested in art and culture in general would find this book an intriguing introduction to these subjects and a response to the question, What is art?

# 1

## What Is Art?

This is a book about Art, what is not Art, and how things come to have meaning and value.

The most powerful and obvious "truths" within cultures are often the things that are not said and not directly acknowledged. In the modern era, this has been the case with Art.

Everything that we know about ourselves and our world is shaped by our histories. Nothing is "natural" in the sense that it can be outside of its particular time and place. When we see, feel, touch, think, remember, invent, create, and dream, we must use our cultural symbols and languages. Among these "languages," Art holds a particularly visible and privileged place. By looking at Art, we can begin to understand the way our representations acquire meaning and power.

To question what is Art and to see it as something that has a specific history and belongs to a particular era can tell us so much about our culture and ourselves.

For example, what would you think if you were told that . . .

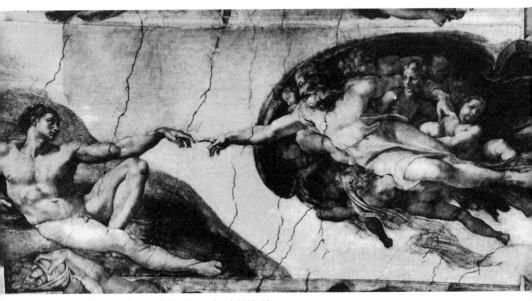

Michelangelo: *Creation of Adam*, Sistine Chapel, 1508–12

This was not Art.

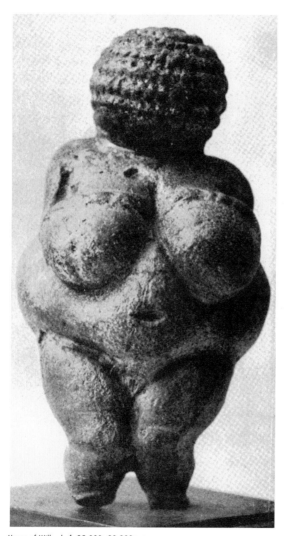

Venus of Willendorf, 25,000–20,000 B.C.

And this was not Art.

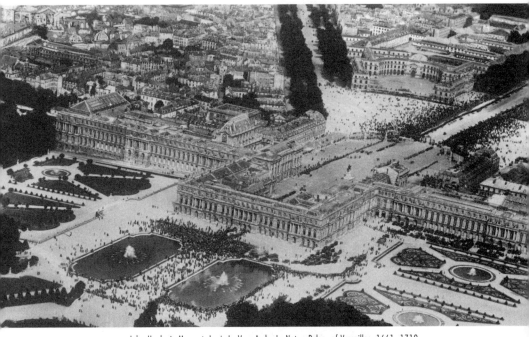

Jules Hardouin-Mansart, Louis Le Vau, Andre Le Notre: Palace of Versailles, 1661–1710

And this was not Art.

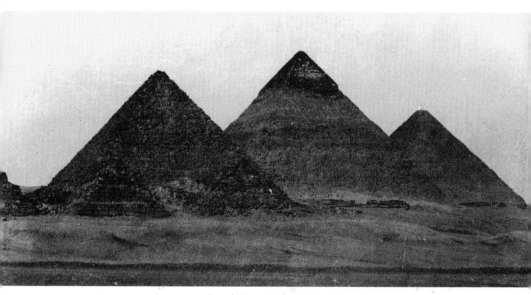

Pyramids, Giza, c. 2500 B.C.

Nor was this.

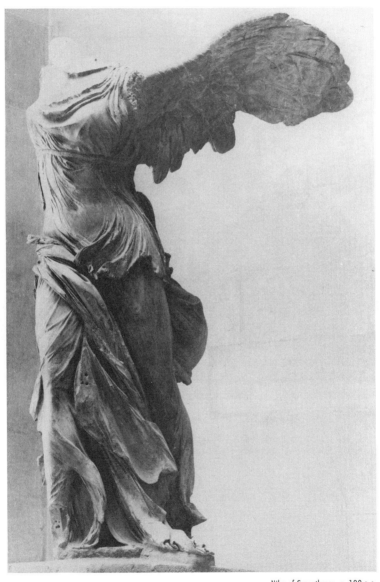

Nike of Samothrace, c. 190 B.C.

Nor was this.

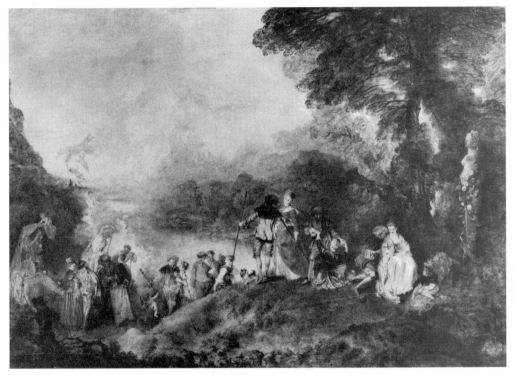

Jean-Antoine Watteau: *Pilgrimage to Cythera*, 1717

Nor was this.

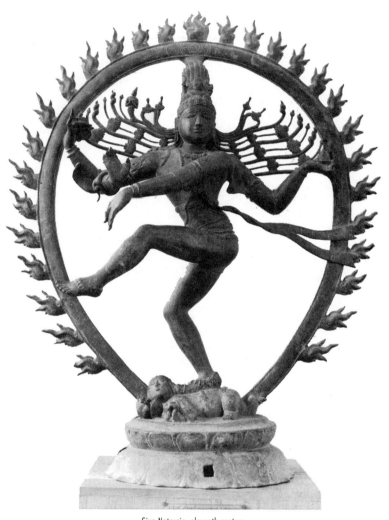

Siva Nataraja, eleventh century

Nor this.

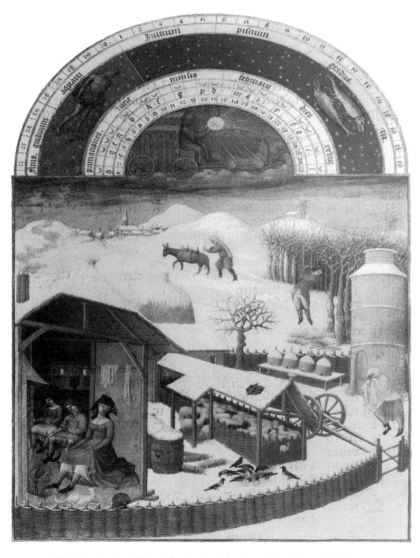

The Limbourg Brothers: "February" from *Les Tres Riches Heures du Duc de Berry*, 1413–16

Nor this.

Reliquary figure, Gabon, Bakota,
late nineteenth or early twentieth century

Nor this.

Detail of votive painting, China, A.D. 983

Nor this.

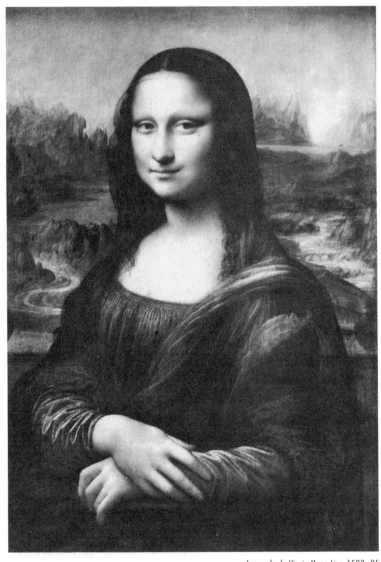

Leonardo da Vinci: *Mona Lisa*, 1503–05

Nor this.

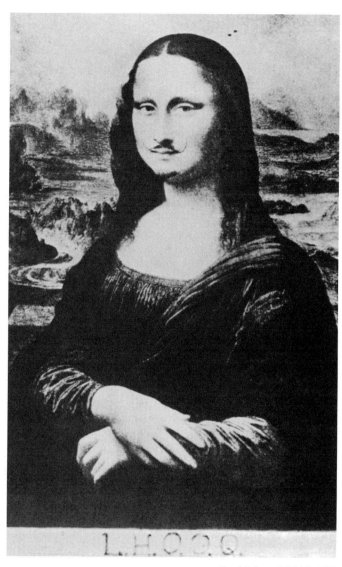

Marcel Duchamp: *L.H.O.O.Q.*, 1919

*This* is Art.

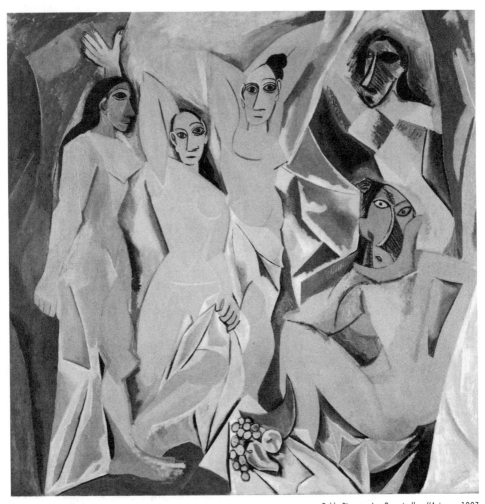

Pablo Picasso: *Les Demoiselles d'Avignon*, 1907

This is Art.

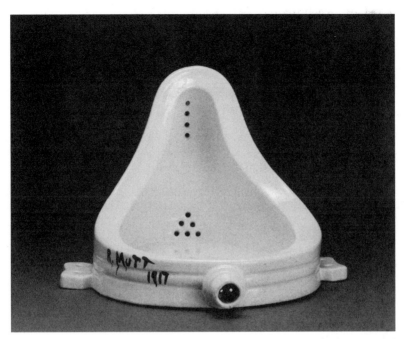

Marcel Duchamp: *Fountain*, 1917

And this is Art.

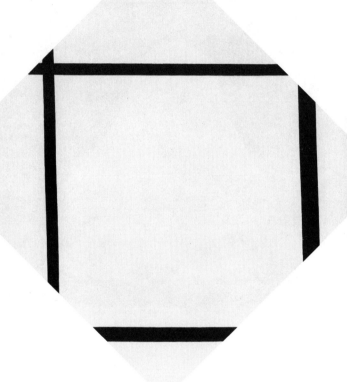

Piet Mondrian: *Painting I*, 1926

And this.

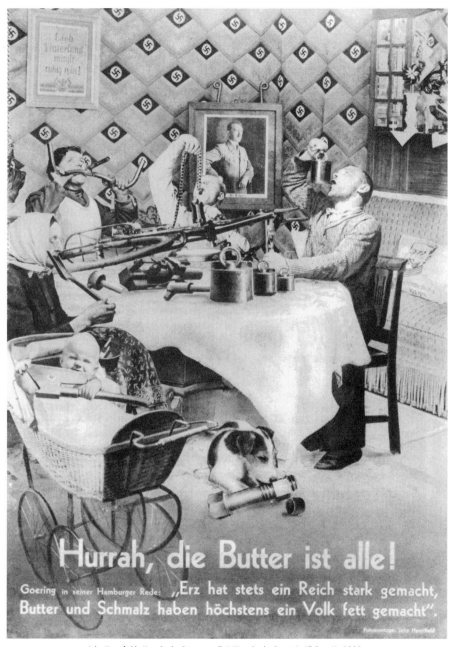

John Heartfield: *Hurrah, die Butter ist alle!* (Hurrah, the Butter Is All Gone!), 1935

And this.

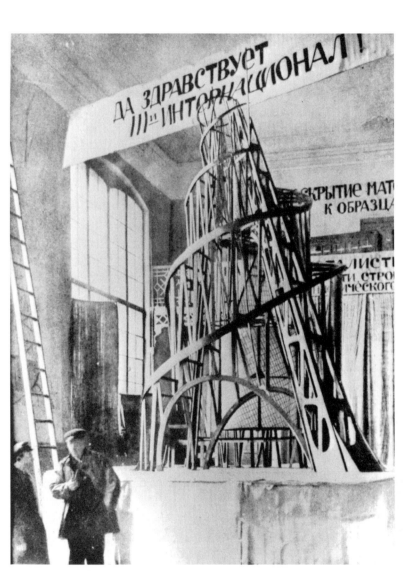

Vladimir Tatlin: Model of Monument to the Third International, 1919–20

And this.

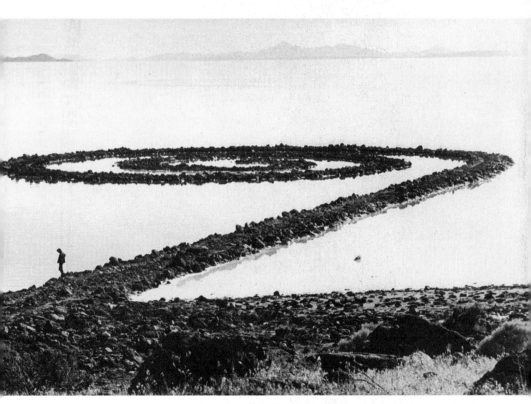

Robert Smithson: *Spiral Jetty*, 1970, photograph by Gianfranco Gorgoni

And this.

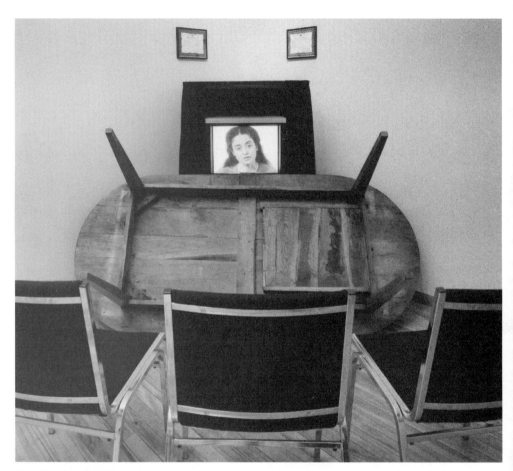

Adrian Piper: *Cornered*, 1988.

And this.

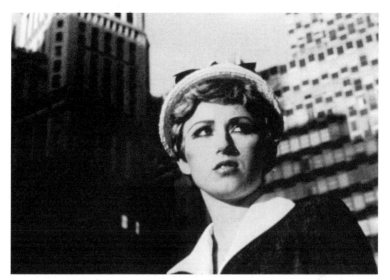

Cindy Sherman: Film still, 1978

Cindy Sherman: Film still, 1979

And this.

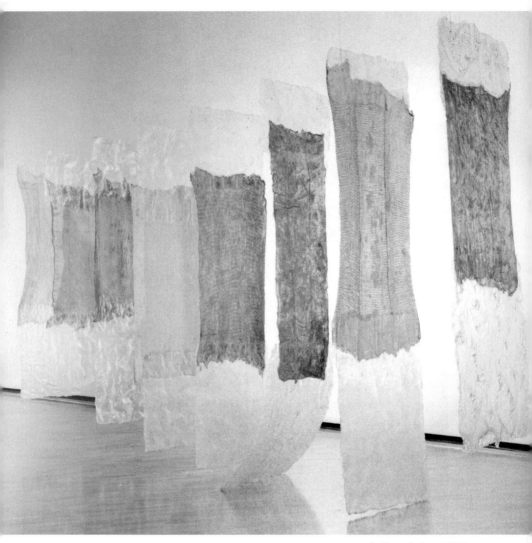

Eva Hesse: *Contingent*, 1969

And this.

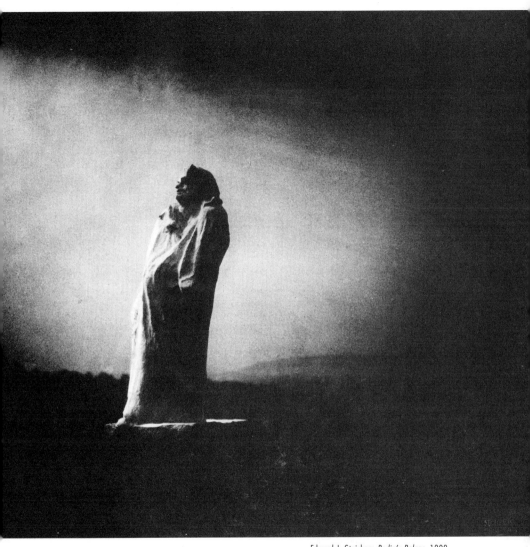

Edward J. Steichen: *Rodin's Balzac*, 1909

And this.

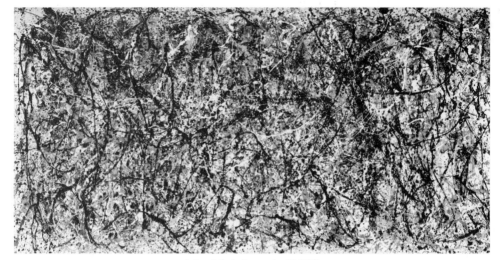

Jackson Pollock: *One, number 31,* 1950

And this is Art.

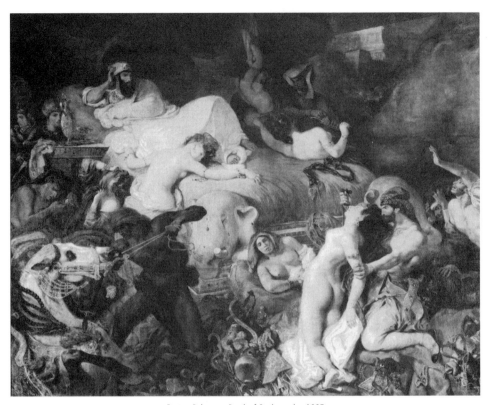

Eugène Delacroix: *Death of Sardanapalus*, 1827

Art.

Art (āɹt), sb. ME. [a. OF. :–L. artem, prob.
f. ar- to fit. The OF. ars, nom. (sing. and pl.),
was also used.] I. Skill. Sing. art; no pl.   1.
gen. Skill as the result of knowledge and prac-
tice.       2. Human skill (opp. to nature) ME.
3. The learning of the schools ; see II.  1.
†a. spec. The trivium, or any of its subjects
–1573.   b. gen. Learning, science (arch.) 1588.
†4. spec. Technical or professional skill –1677.
5. The application of skill to subjects of taste,
as poetry, music, etc.; esp. in mod. use : Per-
fection of workmanship or execution as an ob-
ject in itself 1620.      6. Skill applied to the arts
of imitation and design, Painting, Architecture,
etc.; the cultivation of these in its principles,
practice, and results.   (The most usual mod.
sense of art when used simply.) 1668.

Joseph Kosuth: "Titled (Art as Idea as Idea)," 1967

Art.

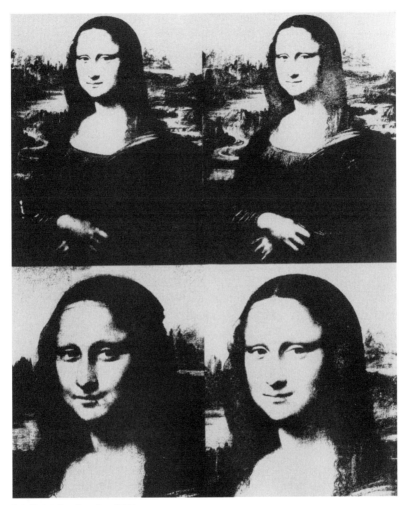

Andy Warhol: *Four Mona Lisas*, 1963

Art.

"Art" is an invention of the modern era—that is, the past two hundred years. The magnificent objects and fragments and buildings created by pre-modern peoples were appropriated by our culture and transformed into Art.

Art, as we know it, is a relatively recent phenomenon and is something made to be seen in galleries, preserved in museums, purchased by collectors, and reproduced within the mass media. When an artist creates a work of Art it has no intrinsic use or value; but when this artwork circulates within the systems of Art (galleries, art histories, art publications, museums, and so on) it acquires a depth of meaning, a breadth of importance, and an increase in value that is greater proportionately than perhaps anything else in the modern world.

Everything in life is shaped and defined by its various institutions. Institutions set up the boundaries and conventions for things— the way a painting's frame shapes its picture and the way a pedestal demarks a particular object as sculpture.

This was one of the things to be seen when Marcel Duchamp began making his "readymades" in 1913:

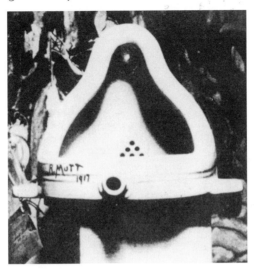

Alfred Stieglitz photograph of Marcel Duchamp's *Fountain* in *The Blind Man* no. 2, May 1917

We "see" this urinal as sculpture because its function changed when Duchamp placed this piece of plumbing within an aesthetic institution—an art exhibition. If you have seen *Fountain* before, most likely it was within an aesthetic institution—for example, a museum or a book like this one. These situations are among the conventions that frame this urinal as Art.

Today *Fountain* is one of the classic artworks of the twentieth century. But the original *Fountain* has disappeared—which is appropriate, considering Duchamp's initial irreverent, anti-aesthetic concerns and his participation in Dadaism. If you see *Fountain* in a museum or a private collection, it is probably one of the editions Duchamp produced in the 1950s and 1960s, when a great deal of the contemporary Art was called "Neo-Dada."

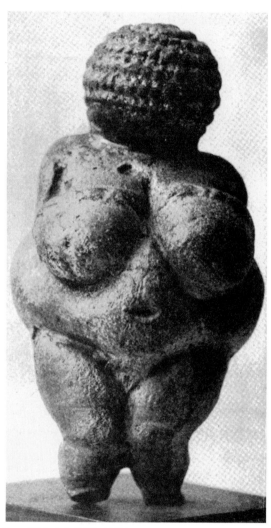

Venus of Willendorf, 25,000–20,000 B.C.

*think back to the*
*quiet interview — bed ,*
*if it's on a bed !*
*it's a quilt .*
*otherwise something*
*it's different*

Similar to Duchamp's *Fountain*, the Venus of Willendorf is seen as Art because its meaning and value for our culture have been created within the institutions of Art—for example, the art histories that have described it.

30

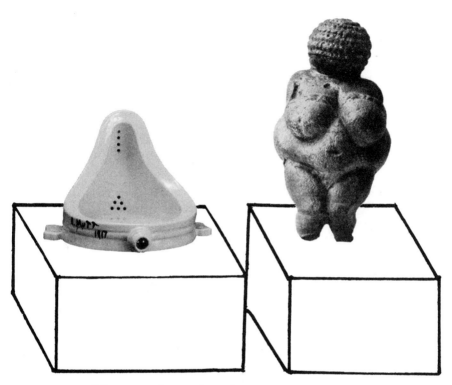

We can understand Duchamp's *Fountain* as a comment on the modern practice of treating and understanding objects from different cultures and periods as Art. In a sense Duchamp's taking a piece of bathroom plumbing, putting it on a pedestal in an art exhibition, titling it *Fountain*, and thereby transforming a urinal into Art is not so different from art historians' taking this 25,000-year-old figurine, placing it in a museum, titling it *Venus*, and christening it Art.

Duchamp has spoken specifically about this in terms of our culture's aesthetic appreciation of African ritual objects as so-called "Primitive" Art, an appreciation that dates primarily from the beginning of the twentieth century: "It is we who have given the name 'art' to religious things; the word itself doesn't exist among 'primitives.' We have created it in thinking about ourselves, about our satisfaction. We created it for our sole and unique use."

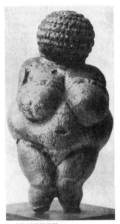

Venus of Willendorf, 25,000–20,000 B.C.

Similar to Duchamp's *Fountain*, the Venus of Willendorf is seen as Art because its meaning and value for our culture have been created within the institutions of Art—for example, the art histories that have described it.

We can understand Duchamp's *Fountain* as a comment on the modern practice of treating and understanding objects from different cultures and periods as Art. In a sense Duchamp's taking a piece of bathroom plumbing, putting it on a pedestal in an art exhibition, titling it *Fountain*, and thereby transforming a urinal into Art is not so different from art historians' taking this 25,000-year-old figurine, placing it in a museum, titling it *Venus*, and christening it Art.

Duchamp has spoken specifically about this in terms of our culture's aesthetic appreciation of African ritual objects as so-called "Primitive" Art, an appreciation that dates primarily from the beginning of the twentieth century: "It is we who have given the name 'art' to religious things; the word itself doesn't exist among 'primitives.' We have created it in thinking about ourselves, about our satisfaction. We created it for our sole and unique use."

This book conforms to myriad institutional frameworks. There are the literal limits of the pages themselves and the enframing covers. But there are the more abstract institutions of art criticism, art history, and critical theory to which my text conforms. I am aware of some of these institutional frames, but some are less obvious, and some I cannot perceive. These frameworks are less obvious because of ideology.

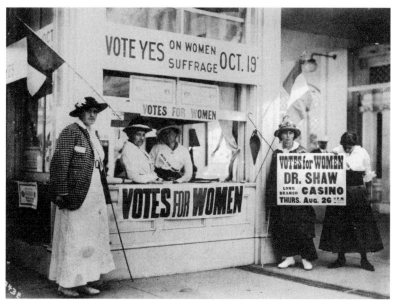

Photograph of Suffragettes in New York, 1914

Almost twenty years ago the novelist and critic John Berger created a TV show and a book about Art, popular culture, and ideology titled *Ways of Seeing*. The questions this program and book raised are the kinds of questions this text is dealing with.

Ideology has been described as our "lived relation to the real." Ideologies appear to be natural or the way things should be. Ideology, like everything, however, is always in flux and is shaped by its particular historical moment. Efficient ideology is accepted and unquestioned. Historical distance often allows us to see ideology at work: A hundred years ago in the U.S. it was generally believed that women should not have the right to vote. This was generally seen as the way life should be. It was "natural" for only men to vote. But this notion was, of course, not natural but ideological.

*medium shapes what the image is.*

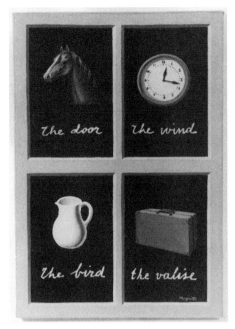

René Magritte: *The Key of Dreams*, 1935

Modern artists have often created critiques of ideological conventions. The first illustration in *Ways of Seeing* is René Magritte's *The Key of Dreams*. Magritte's painting calls into question the way our representations acquire meaning for us—and the way things take on meaning through arbitrary cultural conventions.

Why, for example, doesn't

mean "the door"?

The way works of Art are reproduced—through mediums like photographs, books, TV, postcards—is similar to the way our reality is always *mediated* by cultural institutions.

Think of a very private thought or feeling. Maybe something you've never told anyone—something that you wouldn't express to anyone else.

To know this, to feel this, you must have used language. To know oneself—in a sense, to be, or to exist to oneself—one must enter culture. One must use cultural codes and languages. In this sense, your identity is founded upon that which is exterior to yourself.

How is "Knowing" "defining" different?

35

Our mediated relation to ourselves, our reality, our culture, is perhaps best understood by looking at Art.

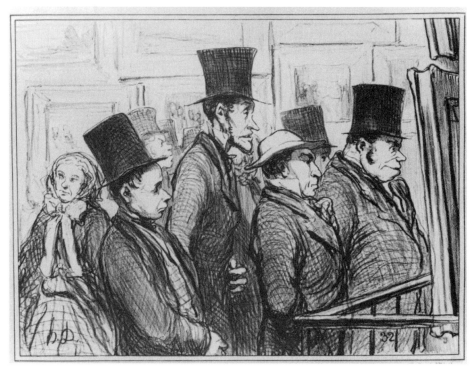

Honoré Daumier: Lithograph published in the journal *Le Charivari*, May 4, 1859

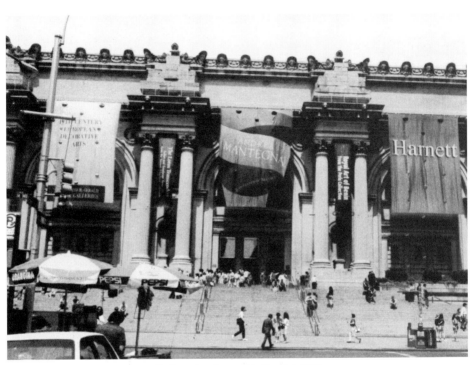

The Metropolitan Museum of Art, New York, 1992

Before the late eighteenth century, the institutions dealing with visual culture were very different from what they are today and in many cases did not exist at all.

# MMA

The Metropolitan Museum of Art,
New York's number one tourist attraction,
invites you to

The Metropolitan Museum of Art visitors' pamphlet

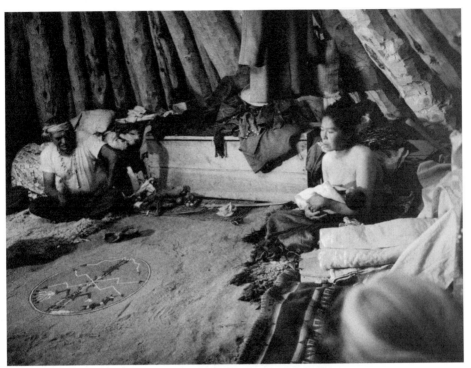

Sand-painting ritual for a sick child, Navajo, Arizona, 1954, photograph by Lee Boltin

Before the late eighteenth century the things we call Art were embedded in the fabric of everyday life.

*material Culture = art ?*

The historical limits of institutions can be found in the way that most of us see Renaissance culture in terms of great masterpieces and works of Art.

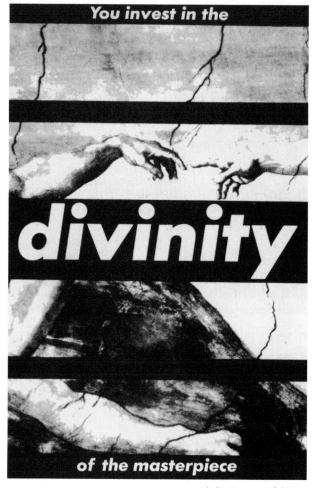

Barbara Kruger, untitled, 1982

The artist Barbara Kruger has made a piece about this. We have psychological, social, and economic investments in seeing the Sistine Chapel as a masterwork of Art.

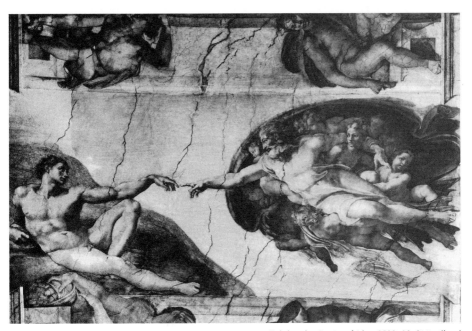

Michelangelo: *Creation of Adam*, 1508–12, Sistine Chapel

Michelangelo's *Creation of Adam* was not Art.

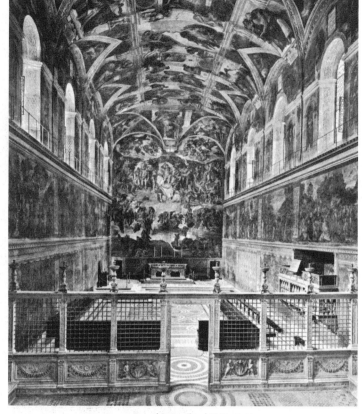

View of Sistine Chapel, Vatican

*The Creation of Adam* is a fragment of a wall fresco that was created to serve as a backdrop for the mysteries and miracles of the Catholic Mass. This image is one part of a complex program of wall decoration in a chapel within what was the center of Papal authority and power in sixteenth-century Rome. The *Creation*'s miraculous naturalism was supposed to mirror—as it literally surrounded—the miraculous celebration of the sacrament of the Eucharist during the Mass. In the Catholic faith, one of the most sacred rituals is this sacrament when the divine is believed to be mysteriously present. Michelangelo's illusionistic transformation of the chapel walls into a visual spectacle reflecting the beauty and horror of nature and humanity served as a metaphor for what was and is believed to be God's creative power.

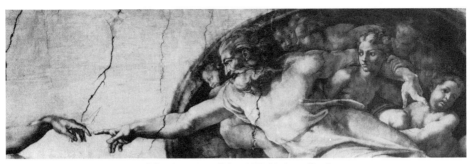

Michelangelo: *Creation of Adam*, 1508–12, Sistine Chapel

However magnificent and beautiful the Sistine Chapel frescoes may be, they were not Art as we know it. They were instruments of religious and political authority. Their magnificence was supposed to be a visual manifestation of the power of the Christian God and, specifically, God's earthly sovereignty manifested in the Della Rovere Papacy.

The function and creation of Michelangelo's Sistine frescoes were very different from those of the things we call Art. Art, as we understand it, is created by an artist who has absolute authority over the work. Michelangelo, however, did not initially want to paint the frescoes. He was ordered to do so by his patron, Julius II. Art in the modern era is not something commanded by papal decree but is made because the creator is compelled to do so. The vision and authority of execution comes from the individual, not from an external political or religious master.

To consider Michelangelo's work Art is to ignore the vast differences between that historical moment and ours. To consider the Sistine frescoes Art is to sever them from their context. For the medium of fresco, in particular, this should be nearly impossible to do. The pigment is applied onto the wet plaster of the wall. The images seep into the architectural support, which in this case is the sacred walls of a papal chapel.

Because of our own historical limitations—what has been called our "horizon of prejudice"—we cannot understand and see the Chapel frescoes as did Michelangelo, Pope Julius II, or a sixteenth-century Catholic. Instead we see this religious structure as a work of Art. Today these miraculous frescoes are among the most visited tourist attractions.

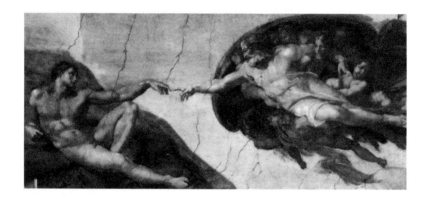

This is a reproduction of a postcard from the Vatican.

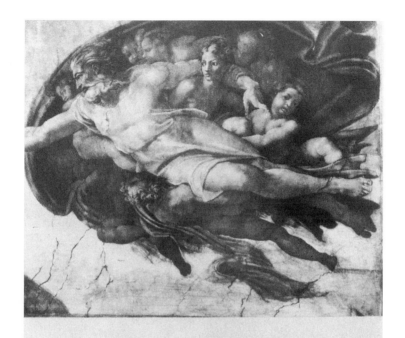

of Adam's body but the passage of the Divine spark—the soul—and thus achieves a dramatic juxtaposition of Man and God unrivaled by any other artist. Jacopo della Quercia approximated it (see fig. 479), but without the dynamism of Michelangelo's design that contrasts the earth-bound Adam and the figure of God rushing through the sky. This relationship becomes even more meaningful when we realize that Adam strains not only toward

Janson's *History of World Art*, 1970 printing, page 360

The proliferation of reproductions in the cultural and mass media has helped us "see" the *Creation of Adam* as a painting.

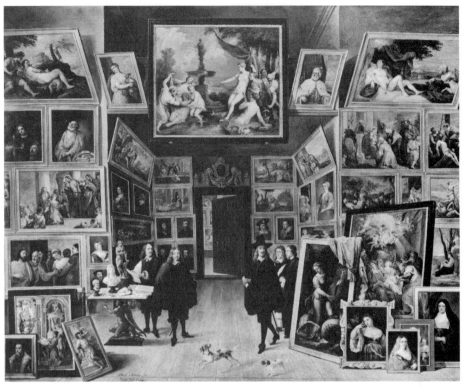

David Teniers: *Interior of the Gallery of the Archduke Leopold of Brussels*, 1647

Most likely you have seen Michelangelo's *Creation of Adam*. But have you been to the Vatican? Most of us know this image because we have seen it in a book; or maybe you were sent a postcard?

Think of the great works of Art you have seen. You've probably seen most of them as reproductions. This imaginary museum we carry within our memories was called "a museum without walls" by André Malraux in 1947.

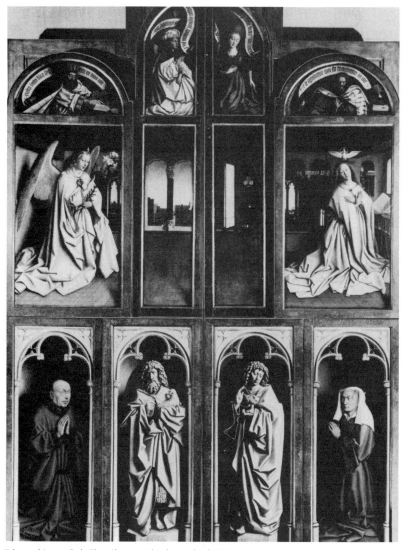

Hubert and Jan van Eyck: Ghent Altarpiece (closed), completed 1432

The famous Ghent Altarpiece is considered a great masterpiece of the Northern Renaissance.

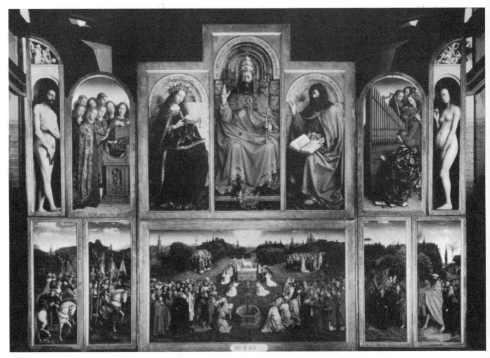

Hubert and Jan van Eyck: Ghent Altarpiece (*opened*), completed 1432

*Religions "artifact" vs Art*

But this is an altarpiece and not a "painting." It might be better to think of the Ghent Altarpiece as a theatrical backdrop for the performance of the Mass. The altarpiece is a large folding screen that would be opened around the altar during the Mass. This would symbolize the disclosure of divine truths in nature, which are made visible in the allegorical images of the panels.

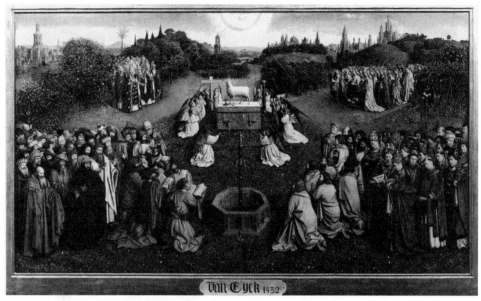

Hubert and Jan van Eyck: *Adoration of the Lamb* from the Ghent Altarpiece, completed 1432

The sacrificial lamb on the interior central panel symbolizes the redemption of humanity. This is the climax and message of the Mass, which is celebrated in the sacrament of the holy Eucharist. The altarpiece's screen of jewel-like images was created to be a mirror of the richness and omnipotence of the Christian God, whose glory was manifested in the stunning vastness and microscopic variety of this illusionistic array.

Think of how the images of the Ghent Altarpiece or those of the Sistine Chapel would appear to a person who might not encounter a single picture in an entire day, or a month, or perhaps a year. Think of the power that these images must have had and how miraculous they must have seemed and how different our experience of them must be—we who are bombarded by hundreds (and if we watch a lot of TV, thousands) of images daily.

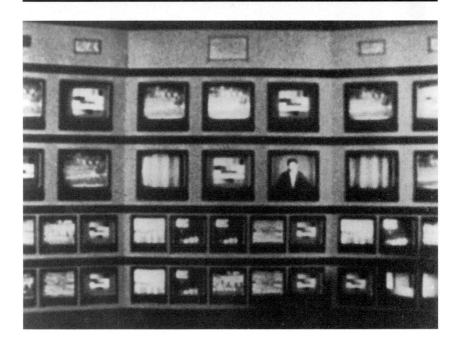

la société
du
spectacle

un film écrit et réalisé par

**Guy Debord**

d'après son livre publié aux Editions Champ Libre

These are film stills from Guy Debord's *The Society of the Spectacle*, a 1973 film that portrays our culture as one driven by consumption, particularly visual consumption.

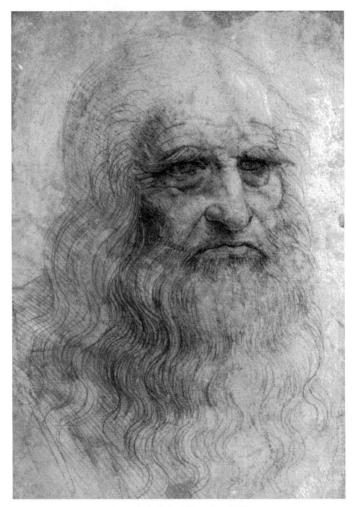

Leonardo da Vinci: *Self Portrait*, c. 1512

Think about the work of Leonardo da Vinci in relation to our notion of artists and their Art.

Leonardo saw his painting and drawing skills as one aspect of his myriad talents and one type of work that he did. When he wrote about his abilities to his future patron, the Milanese duke Ludovico Sforza, Leonardo described his knowledge of civil and military engineering, his inventions, and only at the very end of the letter did he mention that he could paint.

Leonardo da Vinci: Anatomical sketch, c. 1510

Leonardo's drawings and paintings must be understood in terms of Christianity and Renaissance Humanism. For Leonardo, his drawing and painting were means of understanding the world. In the Renaissance, seeing, observing, and recording were means of acquiring the knowledge that led one to wisdom—a kind of wisdom that brought one closer to a divine state of Grace.

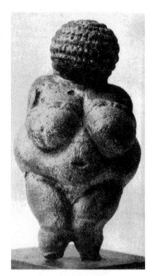

Venus of Willendorf, 25,000–20,000 B.C.

Many of the well-known histories of Art begin their story with the Venus of Willendorf.

This five-inch-high figurine was created approximately 25,000 years ago. We do not know how this object functioned, or who made it, or what the people who used it were like, or what their beliefs and rituals were. The name "Venus of Willendorf" and the idea to consider this Art are the notions of modern art historians.

In a sense, it is ridiculous to consider this figurine Art—or sculpture, for that matter. This is not to deny that it possesses to our eyes an eloquence of form. And maybe when the Venus was created, it was considered to be an especially important object.

But maybe it was one of many. Maybe the Venus was a commonplace object of everyday use. To call this figurine Art is, in a sense, presumptuous, and it ignores the thousands of centuries that separate us from it and those who first created this figure.

Similarly, the cave paintings at Lascaux were not Art, yet it has been a commonplace for critics to write about "the artist" working in the caves. The important American critic Clement Greenberg in one of his most influential essays, "Modernist Painting," has written:

> The Paleolithic painter or engraver could disregard the norm of the frame and treat the surface in both a literally and virtually sculptural way because he made images rather than pictures, and worked in a support whose limits could be disregarded because (except in the case of small objects like a bone or horn) nature gave them to the artist in an unmanageable way.

Now, to write about a Paleolithic artist "disregarding the norm of the frame" is as ridiculous as it is to think about the power and meaning of these images on cave walls in terms of "a painting" and its frame.

The exact purpose of these images on the walls of the Lascaux caves and why they were appreciated is lost to us. We should respect this loss and the unfathomable remoteness of their history.

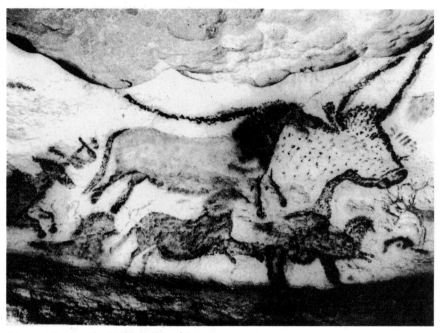

Cave painting from Lascaux, c. 15,000–10,000 B.C.

The caves at Lascaux were discovered by our civilization in 1940, and today the caves are famous "works of Art" and tourist attractions. But visitors to the caves see what is called Lascaux II, a "simulacrum" (to use the theorist Jean Baudrillard's term) of the original caves. Since 1963 the original caves have been closed to the public in order to preserve them, while in a quarry nearby a fascimile of a section of the caves was opened to the public in 1984. Which is now the Art? The closed "original" caves or the replicas that are admired by visitors?

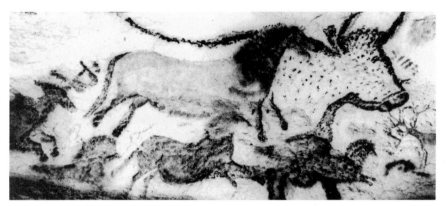

Cave painting from Lascaux, c. 15,000–10,000 B.C.

In the late 1980s and early 1990s more Lascaux simulacra have been made. Another section of the caves was created for the Universal Exposition in Fukuoka, Japan, and this is now part of the collection of the Musée d'Aquitaine in Bordeaux. A replica of this simulacrum is now also exhibited near the original caves in France. And in 1993 a third simulacrum became a feature of the Hall of Human Biology and Evolution at the American Museum of Natural History in New York.

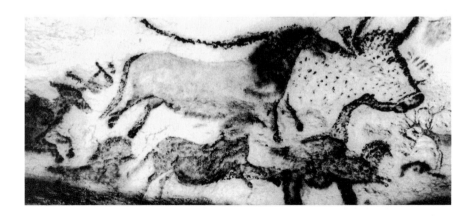

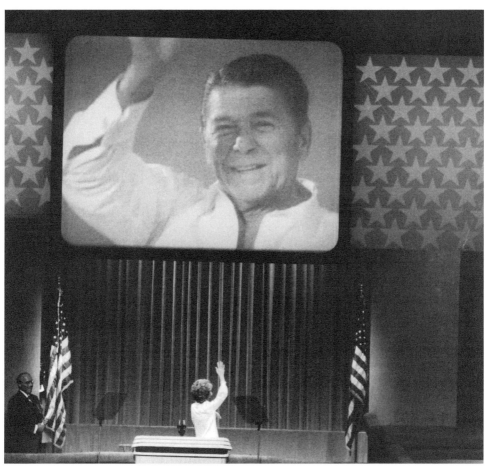

Photograph of Nancy Reagan at 1984 Republican National Convention with the caption "FAN CLUB: Nancy Reagan and Her Screen Idol" in *The New York Times* August 23, 1984, p. A24

Today we live in a world where the image, the reproduction, is more powerful than the original.

# 'It was like the Wizard of Oz'

By PETER MOSES
and LEO STANDORA

Residents of a Putnam County condominium last night described a roaring nightmare that in a few seconds turned their lives upside down.

"I'd just got home from work when I heard a sound," said Douglas Molloy, 37. "It almost sounded like a train coming by. It was a low steady rumble. Then I saw debris — pieces of the condo flying in the air."

"What we had here was a tremendous blow-down. It was all in one direction. The wind was absolutely tremendous. It was worse than any thunderstorm I'd ever seen," said Carmel Fire Chief John Copland.

At least 200 people were left homeless after the twister hit the King's Grant condominiums in Carmel were taken to a temporary shelter set up at Carmel HS.

They left behind a ruined landscape that had been their homes — roofless and windowless townhouses, and insulation hanging from trees like moss in a bayou.

Other trees, some six feet in diameter, had been uprooted. A building that stored garbage bins was completely destroyed with no trace of the bins.

Mike Corrigan, 30, a Put-

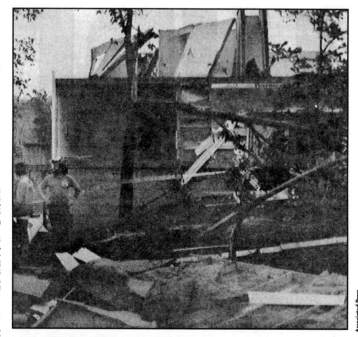

**GONE WITH THE WIND:** *King's Grant condominium complex in Carmel, N.Y., fell like a house of cards — with damage to about 35 of the 85 buildings in the complex. But miraculously there were only minor injuries.*

nam County police detective was eating dinner with his wife Sharon and their 2-year-old son.

"You could hear the wind winding up. It started low. We thought what was that. It just got louder and louder so you couldn't hear. Trees were bending. Rooftops and walls were blowing right by."

"I realized we should go to the basement. I picked up my son and right after I had him in my arms and started downstairs our sliding patio door blew right in. It exploded."

Mrs. Corrigan said, "It was a nightmare. It was over in seconds. This is the kind of thing you see on the news, but you never think it can happen to you."

Gordon O'Neill, 18, who lives in the area, said, "It was like the 'Wizard of Oz,' the wind, things blowing around, the darkness."

The northwest section of the 85-building complex — where townhouses cost from $150,000 to $180,000 — was hardest hit, with damage to about 35 of the wood-frame buildings.

Only two people were hurt. A 33-year-old man suffered cuts and and a 35-year-old woman stepped on a nail.

"A lot of people were not at home. They were working. That might explain why there were so few injuries," said Carmel Police Sgt. Michael Johnson.

Elsewhere in Carmel, racehorse groom Klaus Schengder said the tornado took a window from their barn, tore up a patch of a field and littered their property with debris.

"A house owned by a secretary who works at the stables is gone — completely — and she doesn't even know it," he said.

"She's in Florida and nobody can reach her."

*From page 2 of The New York Post, July 11, 1989, reprinted with permission*

Think about the way people react to unusually exciting, tragic, or romantic experiences by saying, "This is just like a movie!"

60

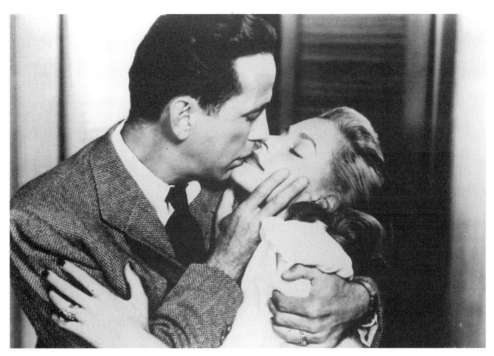

Film still from *Dark Passage*, 1947

Film still from *Mr. Blandings Builds His Dream House*, 1948

The movies and the mass media shape our expectations, our
hopes, our dreams.

Wedding photograph, New Jersey, 1954, photograph by Gustave O'Biso

These images and our lives often mirror each other.

Film still from *Father of the Bride*, 1950

These images reinforce our conventions about the way the world should be

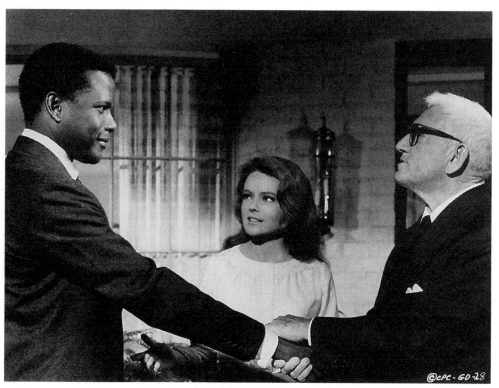

Film still from *Guess Who's Coming to Dinner*, 1967

and the way things change

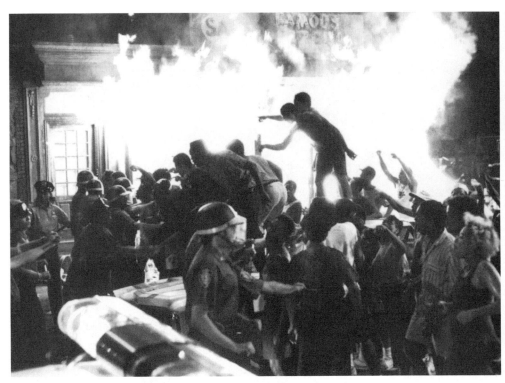

Scene from *Do the Right Thing*, 1989, photograph by David Lee

and need to change some more.

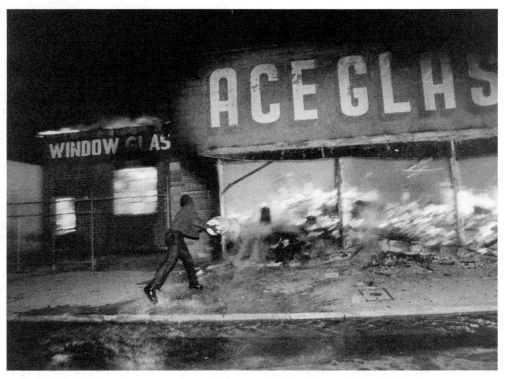

"King Case Aftermath: A City of Crisis," "Reign of Fear and Violence," *Los Angeles Times*, May 1, 1992, page A 5: Cornelius Pettus, age 33, tries to help quench the flames that engulfed the Ace Glass Shop at Western and Slauson Avenues the night the Rodney King verdict was announced. Photograph by Hyungwon Kang/L.A. Times.

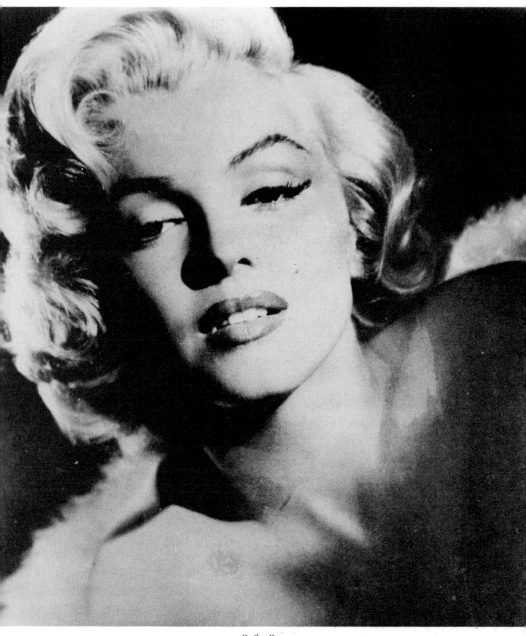

Marilyn Monroe

This is the power of the public image.

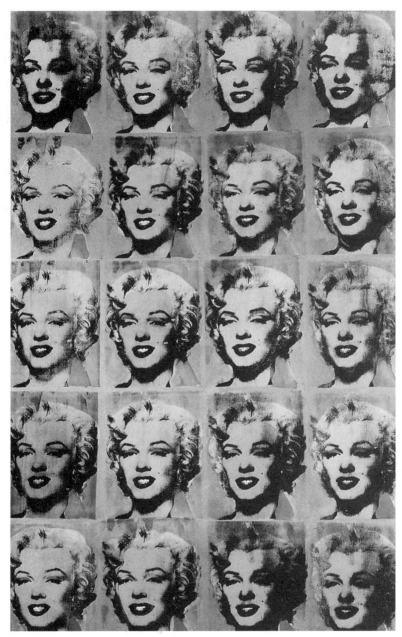

Andy Warhol: *Marilyn Monroe,* 1962

This is what Andy Warhol made visible about our culture.

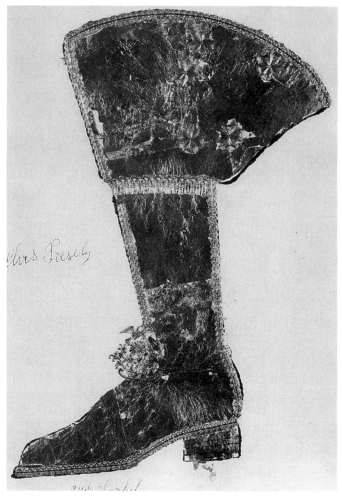

Andy Warhol: *Elvis Presley Boot,* c. 1956

In the 1950s Warhol, working as a commercial artist, pictured Elvis Presley as the fan of a celebrity would. Warhol equated the power of Elvis with glamour, fashion, and stardom and portrayed him as a commodity fetish, a gold, tinfoil silhouette of a shoe.

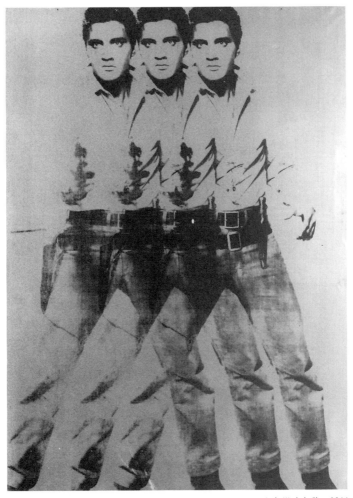

Andy Warhol: *Elvis*, 1964

But in the 1960s Warhol re-evaluated and relocated the power of stardom within the repetition of reproductions that engender celebrity. In this painting we see the currency of images that create a public image. Warhol in this portrait of Elvis makes visible the way the meaning and value of celebrity is produced.

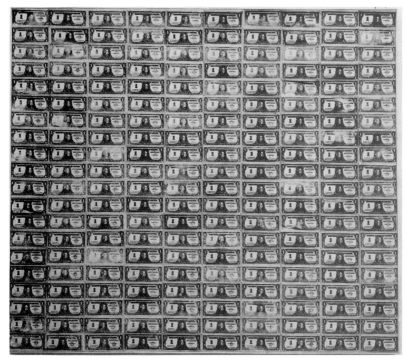

Andy Warhol: *Dollar Bills*, 1962

This circulation of public images—which functions as a currency—is similar to the way a dollar bill acquires meaning and value. In these paintings from the 1960s, Warhol illustrated that stars are born within the same abstracted domain where the meanings and values of our society are created.

(opposite) Film still from *Jail House Rock*, 1957

The media is an abstracted, almost mysterious "space" that, in many ways, unites the world. For example, in 1988, everyone on the planet Earth near a TV set could have watched the Winter Olympics.

The "snow" that you see in this picture is actually sand, which was used because it looks more like snow than real snow when reproduced on television. An Olympics spokesperson said: "The sand looked more uniform, it wouldn't melt, wouldn't get dirty, wouldn't reflect into the camera. It looked like snow, but didn't have any of the problems of snow. . . . Besides, you could rake it and make it smooth in between performances." The sand was more picture-perfect than snow, and only the people in the stadium saw that it was sand. In a sense, the "real" Olympics were only visible on the TV screen.

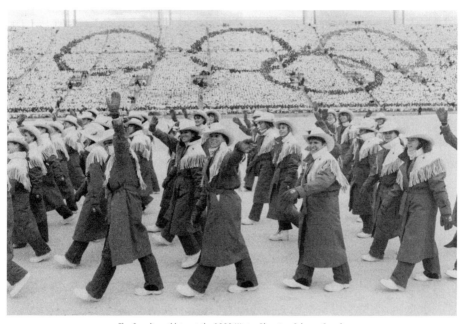

The Canadian athletes at the 1988 Winter Olympics, Calgary, Canada

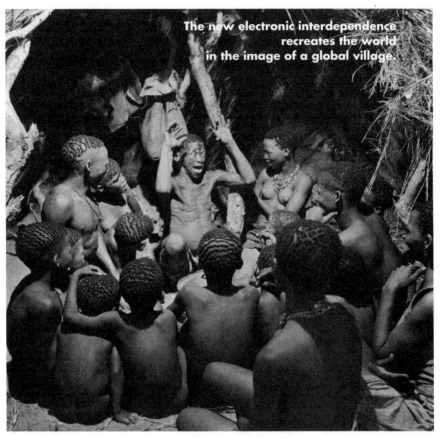

The new electronic interdependence recreates the world in the image of a global village.

Marshall McLuhan and Quentin Fiore: *The Medium Is the Massage: An Inventory of Effects,* 1967

In the 1960s Marshall McLuhan wrote about the media uniting all the people of the world simultaneously. Using this well-known but now somewhat outdated "Primitivistic" picture, he described this situation as a "Global Village."

Like our notion of Art, photography and the creation of mass media are phenomena unique to modernity.

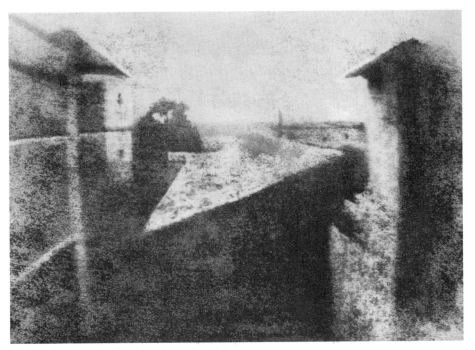

Joseph Nicéphore Niépce: *"The World's First Photograh,"* 1826

Jean-Auguste-Dominique Ingres: *The Valpincon Bather*, 1808, oil

Jean-Auguste-Dominique Ingres: *The Bather*, 1808, watercolor and gouache over graphite on paper

And it is perhaps no coincidence that photography was perfected in 1839, a time when a cult of originality began to develop within modern art. The importance of a unique, original work of art took hold about the time photography was invented. In the eighteenth and early nineteenth centuries, great masters like Ingres would replicate their paintings, making many versions of the same composition. For example, there are four oil versions of *Raphael and the Fornarina*, as well as drawings and tracings. In keeping with old master studio practices, Ingres's assistants would often execute a great deal, if not all, of the composition. For the version of *Antiochus and Stratonice* now owned by the Musée Conde, Ingres conceived the image, but his assistants painted the canvas. One pupil described the creation of *Stratonice*: "Ingres was extreme. He wept from it. He recounted the subject many times while we worked on it."

Jean-Auguste-Dominique Ingres: *Antiochus and Stratonice*, 1840, Musée Conde, Chantilly

Etienne Carjat: *Portrait of Charles Baudelaire*, 1863, photograph

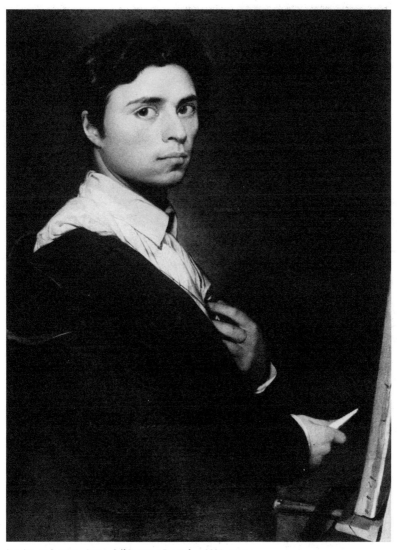

Jean-Auguste-Dominique Ingres: *Self Portrait at Twenty-four*, 1804, painting

Art, like photography and popular culture, is a field of representation that is unique to modernity. To emphasize the fact that Art is a modern cultural category and to demonstrate the way modernity has evaluated all cultures according to modern aesthetic criteria is not meant to destroy appreciation of the things we call Art; rather it is meant to augment our understanding of cultural creations both different from and including our own. In many cases, the only remains we have of pre-modern cultures and civilizations are the objects and fragments and structures that we now treasure as Art.

*Modernity is really being defined here.*

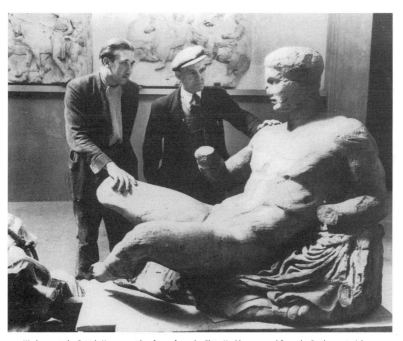

Workmen at the British Museum with a figure from the Elgin Marbles removed from the Parthenon in Athens

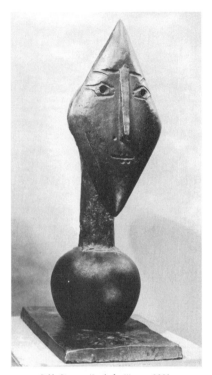

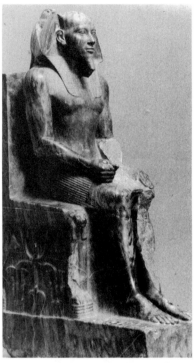

Pablo Picasso: *Head of a Woman*, 1951

Chephren, c. 2500 B.C., from Chephren's temple, now in the Egyptian Museum, Cairo

We should respect the differences and distances between this sculpture by Pablo Picasso, and this representation of the Egyptian pharaoh Chephren. The Egyptian figure was not Art; rather it is among a number of similar statues that were part of a necropolis created in 2500 B.C.

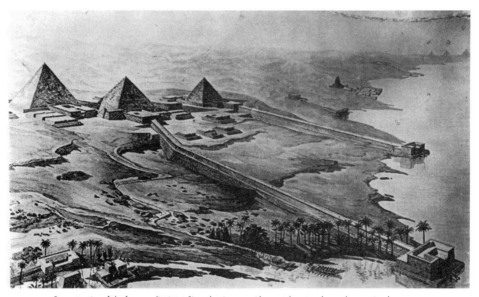

Reconstruction of the funerary district at Giza, showing pyramids, mastabas, temples, and processional causeway

These pyramids, their temples, and the artifacts within them composed the massive ritualistic royal funerary district at Giza in ancient Egypt. The pharaoh's portrait was one of many statues and artifacts within this complex that were not made to be seen and exhibited; they were created to be buried and preserved for the afterlife in the temples and chambers of the pyramids.

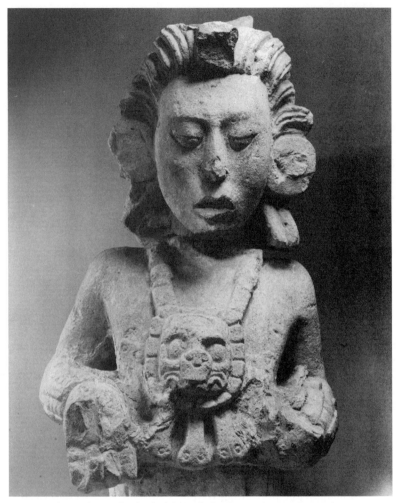

Maize god, Mayan fragment from facade of the Temple of Meditations, Copan, Honduras, sixth century A.D.

Our appraisals of foreign, ancient, or so-called primitive cultures are judgments limited by our standards. For example, the ancient Mayans didn't even have a word or synonym for our concept Art. Art, as we know it, was an idea a Mayan in the sixth century could not think.

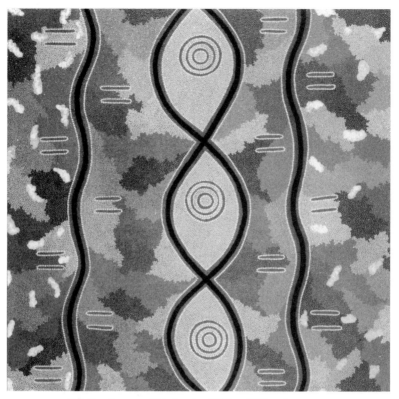

Colin Dixon Tjapananga: *Water Dreaming at Billidanu*, 1988, acrylic on canvas

Today the transformation of non-Western culture into Art continues. The art world has relatively recently begun marketing the paintings of Australian Aborigines. The Aborigines make sacred images on sand, bark, rock, and even their own bodies, and these practices and artifacts have been appreciated for their aesthetic qualities since the 1920s and 1930s. In the 1970s, however, a Caucasian schoolteacher, Geoff Bardon, introduced canvas and acrylics to the adults of an Aboriginal government settlement where he had come to teach Art to children at the school. This led to an explosion of activity, and these transpositions of tribal ritual images in acrylic on canvas are now highly sought after in the art world. Many of the Aborigine artists have celebrated careers, and their creations sell for fabulous sums.

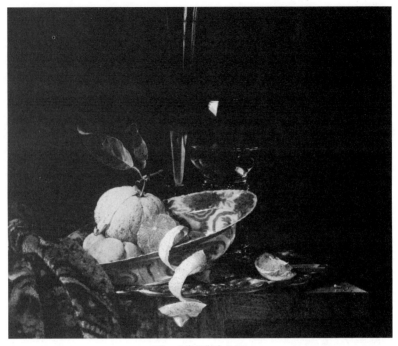

Willem Kalf: *Still Life*, 1659

This is a painting from seventeenth-century Holland. It is a prototype for painting as we know it. Still-lifes, like this one, were bought and sold within the seventeenth-century European art market—which was a prototype for the art system that we have today. The market for pictures was particularly strong among the middle classes of the burgeoning capitalism of the Netherlands. But this still-life is a "vanitas" image and so is very different from the still-life produced in the modern era. This picture of wine and fruit is an allegory of the vanity and transience of human life. The symbols and messages of vanitas paintings were understood by the seventeenth-century public. The lemon conventionally symbolizes deceptive appearances. The orange, just beginning to swell and rot, is a metaphor for the passage of time. The dazzling flecks of light are references to the fleeting moments of mortality.

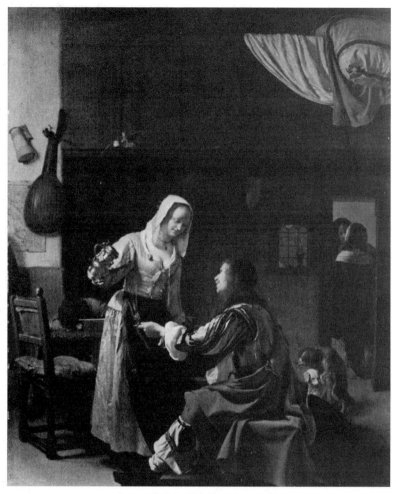

Frans van Mieris the Elder: *The Brothel,* c. 1650

This vanitas painting has a message that is more obvious to our modern eyes. Although these paintings have a lot in common with contemporary Art, they functioned differently than Art does in modernity and were understood in terms of very specific and commonly known moral messages.

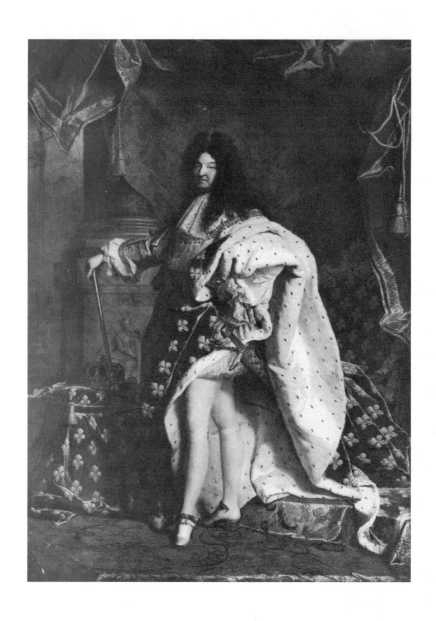

This 1701 portrait of Louis XIV by Hyacinthe Rigaud,

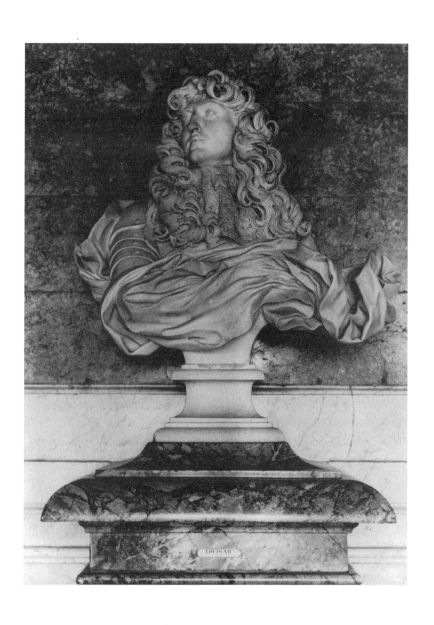

this 1665 sculpture of Louis XIV by Gianlorenzo Bernini,

91

Attributed to André-Charles Boullé, c. 1675–80. The door panel features a triumphant French cock

and this painted door panel from a cabinet were not Art.

*Only after time for function has passed is it transformed to Art, transp. a new function? value ??*

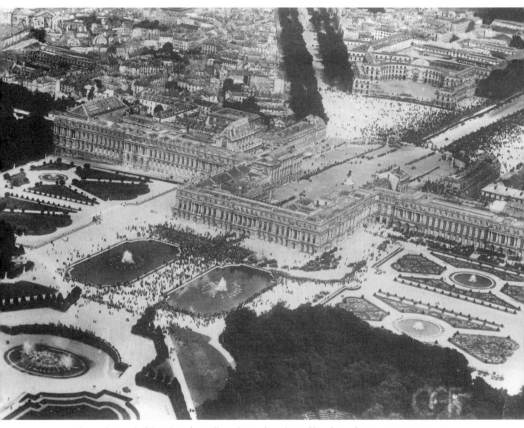

Aerial-view photograph of the Palace of Versailles and its gardens, designed by Jules Hardouin-Mansart, Louis Le Vau, Andre Le Nôtre, 1661–1710

They were made for Versailles, a palace complex that symbolized the absolute power of the Sun King.

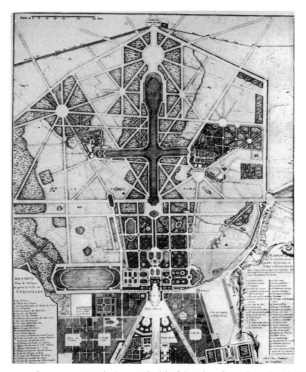

Plan (after a seventeenth-century engraving by François Blondel) of the Palace of Versailles, related buildings, the surrounding park, and a portion of the town of Versailles

Versailles was a royal hunting lodge outside of Paris that Louis XIV (1638–1715) expanded and transformed into a massive palace complex, a vast park, and a satellite town. From a bird's-eye view we can see that the palace is the center of a sunburst (the exact center was the monarch's bedroom). The radiating "rays" of the sun are formed by three avenues that traverse the town (the central road leads to Paris) and converge in front of the chateau. In the back of the palace, roads, paths, and waterways dissect formal gardens (the grand canal on the central axis is more than one mile long). The gardens and town were designed with a geometric symmetry that becomes more diffuse where these areas merge with the forest. The palace, garden, town, and system of roads were supposed to be a living testament that both humanity and nature were prescribed within the design of the Sun King.

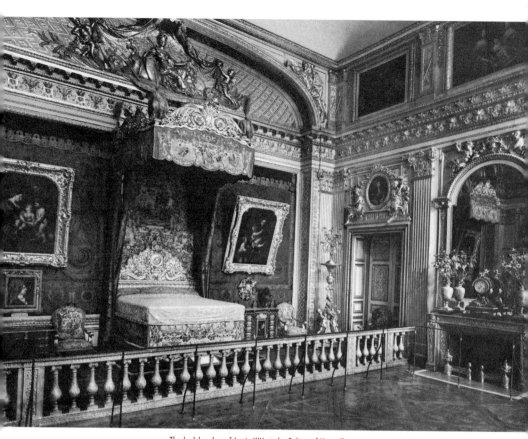

The bedchamber of Louis XIV at the Palace of Versailles

Louis XIV orchestrated his life and his reign to secure the myth of his absolute power. He lived his life in public with the royal court gazing upon his eminence, which also ensured his own surveillance of the aristocracy and royal officials. Louis XIV's mastery of the cult of monarchy was realized when he oversaw the creation of the palace complex and in 1682 moved the court from Paris to Versailles. Every detail and every moment of life at Versailles manifested the rigid hierarchy of rank that placed Louis XIV at the pinnacle from which power flowed.

If you lived or worked in Versailles, your life was, in a sense, a performance demonstrating the myth of the omnipotent authority of the king. If you were a member of the court, for example, your beauty, your wit, your pedigree were representations of Louis XIV's attributes. Among the most extravagant spectacles of the king's sovereignty were the royal festivals, like the parties held in the Hall of Mirrors, which had ceiling murals glorifying Louis XIV, gold and silver chairs, and bejeweled trees. All of this, as well as the invited guests in their dazzling finery, would be magnified and repeatedly reproduced in the mirrors, creating an architectural and living spectacle with one message: the infinite magnificence and radiance of the Sun King.

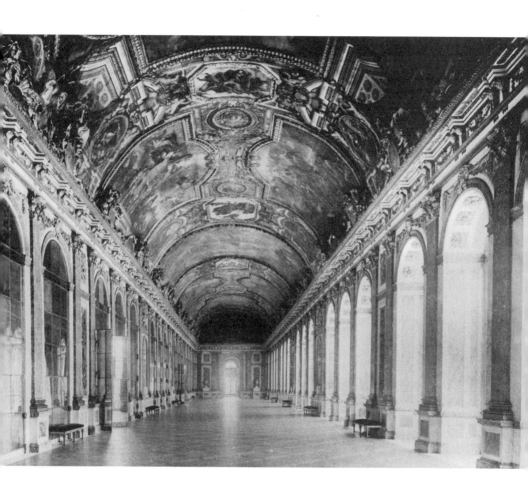

*Versailles, park,* 1901, photograph by Eugène Atget

(*opposite*) Martin Desjardins: *Diana, The Evening* (from a series of sculptures, *The Four Times of Day*), 1680, park of Versailles

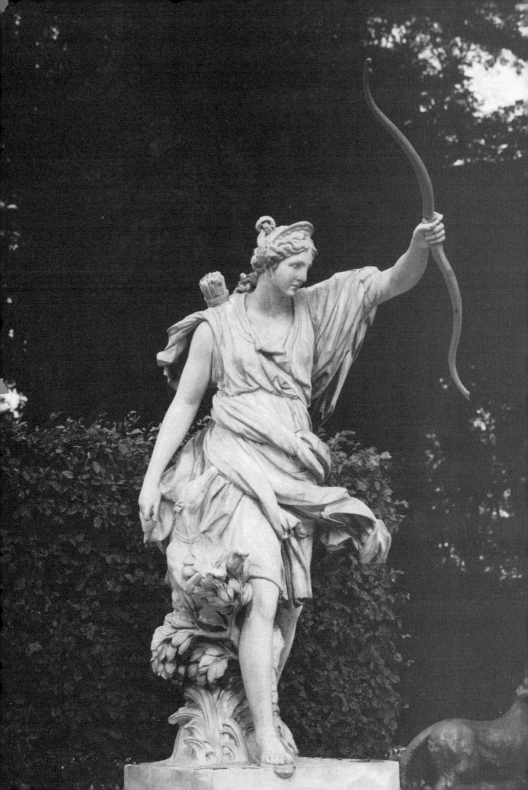

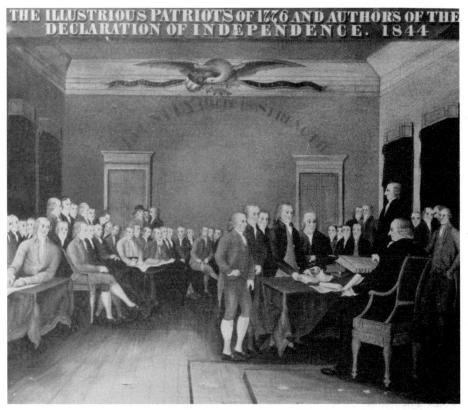

Edward Hicks: *Declaration of Independence*, 1844

# 2

# Art and the Modern Subject

Art, as we understand it, develops in conjunction with a revolutionary transformation of the way in which an individual conceives his or her humanity in Western culture.

It is precisely at the end of the eighteenth century that the modern paradigms of capitalism and the liberal democratic state consolidate. The American Revolution of 1776 and the French Revolution of 1789 were realizations of the idea that an individual is no longer a subject of a monarch but a citizen among other citizens who are all born with inalienable rights. Although aspects of the modern notion of individual rights existed within many premodern monarchies and although vestiges of monarchy are still in existence today—in England, for example—at the end of the eighteeenth century there was a "paradigm shift" in Western political structures and subjecthood.

In the modern Western liberal democratic state, the individual is no longer part of a natural order of things in which everyone is born to a specific rank within a social hierarchy that places the king at the pinnacle. The modern individual is no longer a subject under the power of a sovereign but a citizen with inalienable rights who is part of a collectivity that is sovereign. It must be acknowledged, however, that these rights were initially, for the most part, reserved for white men. The modern era nonetheless inaugurates a sense of self whereby the individual is thought to be king of "his" own castle and the master of "his" own fate, body, and mind.

101

Art came into being in the late eighteenth century when the authority of the European monarchies began to dissolve. This change in the West's social and political fabric is exemplified by the situation in France: In the modern era, France has been, at various moments, the center of Western culture. The French Revolution of 1789 signaled the beginning of the shift in Western culture to the middle-class, capitalist state. Although the French monarchy was successively dismantled and restored throughout the nineteenth century, the Revolution of 1789 represented the beginning of the dissolution of the authority of the monarchy and the inauguration of liberal democracy.

The modern capitalist state finds its most magnified form in the United States—a nation born in 1776, spanning the history of modernity, and manifesting modernity's character and contradictions more clearly than any other nation.

With this change in economic and political structures came a change in the way individuals thought about their identities, their humanity, and their relation to the world around them: The shift from a monarchical rule to a liberal democratic one heralded a restructuring of subjecthood in Western culture whereby individuals are citizens who are supposed to have "free will."

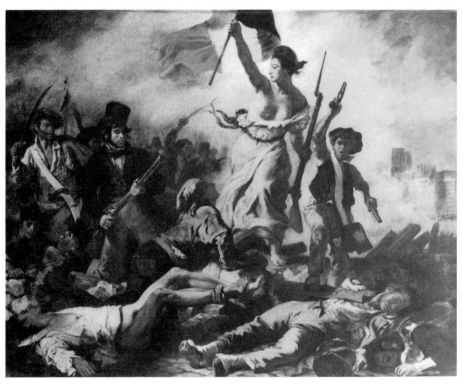

Eugène Delacroix: *Liberty Leading the People,* 1830

Art makes visible the terms of subjecthood within a liberal democracy and capitalism. In the Anglo-American tradition of law, for example, the rights-bearing individual is represented by two paradigmatic rights: property and contract. The right to own something and the right to exchange it.

Art-as-we-know-it is an emblem of these rights of modern subjecthood. In modernity, visual culture does not embody the mysteries of myth and ritual conjured by powers beyond humanity. It is not produced upon command of church or crown. Its maker does not subscribe to the dictates of an academy run by the state. Traditionally, great modern Art is made by one creator, who is inspired to produce it. This kind of inspiration has been understood as the rare gift of genius.

Art functions as a demonstration of its maker's freedom, and it exemplifies the modern subject's right to own something and exchange it. A work of Art has traditionally been seen as the artist's absolute property, a surrogate for and realization of his or her essential self. The artwork when exhibited and exchanged within the "free market" acquires its meaning and value.

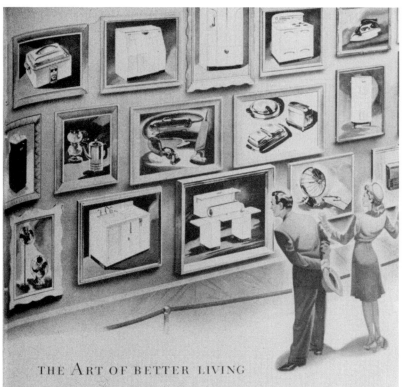

# THE ART OF BETTER LIVING

*Yesterday . . . Today . . . Tomorrow . . .*
*it's Electrical Living by Westinghouse*

Let's hope it's not too far away . . . that bright new day when you'll again know the lift of living electrically. And when it does come, Westinghouse will be a name to remember. It stands for the know-how and experience acquired in making 30 million pre-war electrical home appliances.

More than that . . . it stands for years of tried and tested background in making not just one or two appliances, but twenty-two different types of electrical servants for your home.

At the moment, we're head over heels building essential war material. And we'll stick to that job until it is done. But when the go ahead signal flashes, you can count on Westinghouse to turn out all the fine new appliances you need to banish

that "never-done" feeling about housework. In war or peace, we take your homemaking problems to heart. The pre-war masterpieces shown above are just a promise of what's to come.

WESTINGHOUSE ELECTRIC & MANUFACTURING CO., MANSFIELD, O.

---

**30 MILLION PRE-WAR**

# Westinghouse

### ELECTRIC HOME APPLIANCES

YOUR PROMISE OF STILL FINER ONES TO COME

---

TUNE IN JOHN CHARLES THOMAS • SUNDAY 2:30 EWT, N.B.C. • HEAR TED MALONE • MON. WED. FRI. 11:45 EWT, BLUE NETWORK

1944 Advertisement

The signature is the mark of authorship and guarantee of authenticity. Think about the way we speak about Art: It is a Manet, a Van Gogh, a Mondrian, a Pollock.

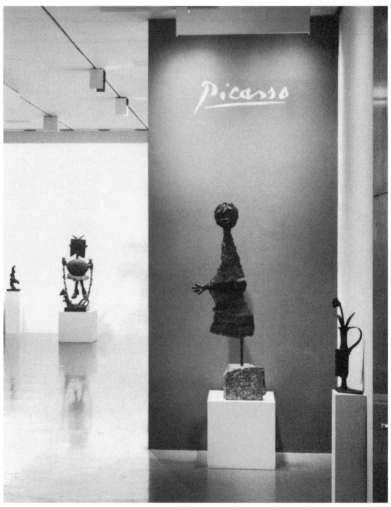

Installation view of exhibition "The Sculpture of Picasso," October 11, 1967, through January 1, 1967, the Museum of Modern Art, New York City

This photograph and magazine project (1985–86) created by Silvia Kolbowski can be seen as a commentary on the aesthetic and commercial value of the signature in our culture.

Think about the significance of the signature and property in terms of graffiti, where the "tag" or signature becomes the image. Despite the fact that graffiti is generally seen as nothing more than defacement of property, it is also a grass-roots street art. In many of its forms, graffiti provides creative activity for urban, and often minority, youths who see their "writing" as a means of naming and claiming public property and giving a voice to those who do not have one. Graffiti is also a visual component of hip-hop and rap culture. Graffiti artists were extremely successful in the art world at one moment in the 1980s, particularly when transferring their creations onto canvas. Ironically, in 1984, at the very moment that graffiti artists began enjoying their celebrity, the New York City Transit Authority instituted a program to remove these markings from its properties. In 1992, for example, New York City spent $7.8 million getting rid of the graffiti on its subway stations and trains.

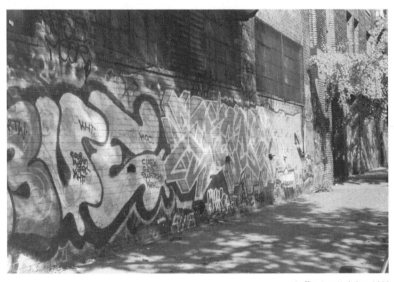

Graffiti, New York City, 1993

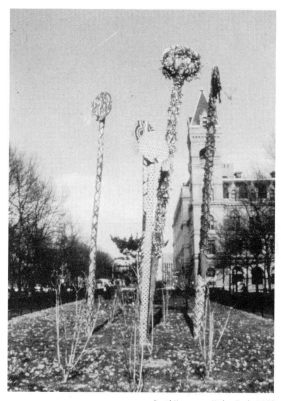

David Hammons: *Higher Goals*, 1983

David Hammons has staged performances and created pieces that subscribe to the fluidity between street life and fine art. His work examines African-American identities, as can be seen in his 1983 piece *Higher Goals*, which was installed in African-American communities, first in an abandoned lot in Harlem and then a park in Brooklyn. These extremely attenuated basketball hoops decorated with bottlecaps foster questions about the goals that black men are supposed to shoot for in our culture. Hammons recycles and plays upon the limiting stereotype of basketball and other sports being these men's only option for success.

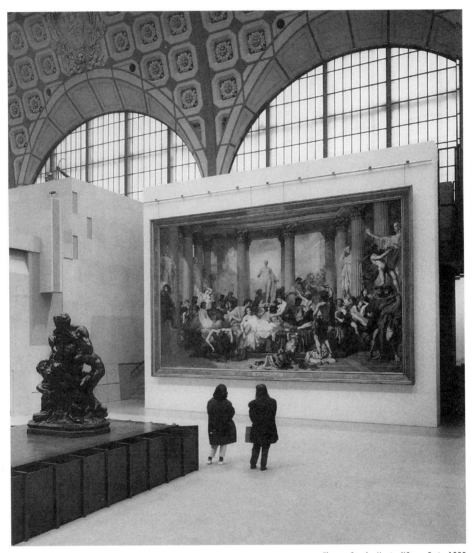

Thomas Struth: *Musée d'Orsay*, Paris, 1989

# 3

## The Term "Art"

The term "ART" as we now understand it began to take on its modern meaning in the eighteenth century: an original creation, produced by an individual gifted with genius. This creation is primarily an object of aesthetic beauty, separate from everyday life. Not solely political propaganda, not a religious nor sacred object, neither magic nor craft, this thing called Art did not exist before the modern era.

Relief depicting a return from the hunt, Asia Minor, first century B.C.–first century A.D.

In Greek antiquity, the synonymous term for Art was broadly applied to all kinds of human endeavor and was seen to be a form of knowledge or craft in which there were rules and skills to be learned. Plato wrote of "art" as the art of painting and sculpture, but he also wrote of the art of hunting, midwifery, prophecy, and mathematics. In modernity, Art has traditionally been understood as something not learned but created, and created by someone gifted with genius. One does not decide to become an artist and then learn how to do so. Artists in modernity are born.

During the Middle Ages, creating the objects we now appreciate as Art was considered a skill that could be mastered. In the thirteenth century, Thomas Aquinas wrote of the arts of shoemaking,

*Agriculture*, c. 1337–43, relief on Campanile of Florence Cathedral attributed to workshop of Andrea Pisano

*Sculptor*, c. 1337, relief on Campanile of Florence Cathedral attributed to Giotto and Andrea Pisano

cooking, juggling, and grammar, as well as the arts of sculpture and painting. Painting, sculpture, and architecture were seen as subdivisions of the mechanical art of construction. The seven canonical mechanical arts included navigation, medicine, and agriculture.

Although the status of artists and their work began to change during the Renaissance and the meaning of Art in the fourteenth and fifteenth centuries had elements of its current usage, the so-called visual arts were seen as something very different from what they are today. It is true, for example, that Italian Renaissance writers and artists argued that painting should no longer be considered a mechanical art. But they thought it should be one of the liberal arts, which included grammar, rhetoric, dialectics, arithmetic, geometry, astronomy, and music.

113

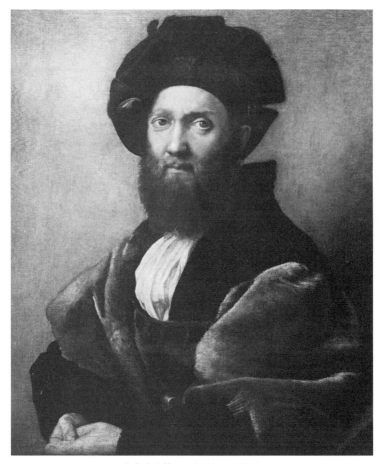

Raphael: *Baldassare Castiglione*, c. 1514

In his attempt to raise the status and appreciation of paint-
ing, Leonardo da Vinci aligned it with scientific endeavors. Count
Baldassare Castiglione in his famous book *The Courtier* (1528) de-
scribed the pursuits appropriate for a Renaissance man and presented
painting, poetry, horse riding, fencing, and coin collecting as equally
valid activities. In Italy a definition of fine art as we know it does not
take hold until the second half of the eighteenth century.

The development of a concept and system of fine art was consolidated in late seventeenth-century France. This involved the study of "The Ancients' " relationship to "The Moderns." The sciences were seen to depend upon mathematics and factual knowledge and were separated from arts, which were thought to be determined by talent and taste. For example, one of the important writers involved in this discourse, Charles Perrault, listed in his *Le Cabinet des Beaux Arts* (The Cabinet of Beaux Arts) eight "fine arts": eloquence, poetry, music, architecture, painting, sculpture, optics, and mechanics. In France, at the end of the seventeenth century, optics and mechanics were thought to be in the same category as painting and sculpture.

It was not until 1746, when Abbé Batteux published his influential treatise *Les beaux arts réduits à un même principe* (The beaux arts reduced to one principle), that the fine arts—music, poetry, painting, sculpture, and dance—were separated from the mechanical arts. Batteux's system was then given widespread currency throughout the European community during the second half of the eighteenth century. In the famous *Encyclopédie* of 1751 and its subsequent reprints, Batteux's system of fine arts was implicitly accepted.

Although the term "beaux art" first appeared in France during the mid-seventeenth century, it did not enter the French language officially until 1798.

It was not until 1880 that the word "ART"—without the French "beaux" in front of it—was found in any English dictionary. Although the modern concept of Art had been used in Western culture for about a hundred years before this date, it was only in 1880 that you found the word Art defined in the modern sense of the term: as "the skilful [sic] production of the beautiful in visible forms" in the official English language.

**Art** (ãɹt), *sb.* ME. [a. OF. :–L. *artem*, prob. f. *ar-* to fit. The OF. *ars*, nom. (sing. and pl.), was also used.] **I.** Skill. Sing. *art*; no pl. **1.** *gen.* Skill as the result of knowledge and practice. **2.** Human skill (opp. to *nature*) ME. **3.** The learning of the schools ; see II. **1.** †**a.** *spec.* The *trivium*, or any of its subjects –1573. **b.** *gen.* Learning, science (*arch.*) 1588. †**4.** *spec.* Technical or professional skill –1677. **5.** The application of skill to subjects of taste, as poetry, music, etc.; *esp.* in mod. use : Perfection of workmanship or execution as an object in itself 1620. **6.** Skill applied to the arts of imitation and design, *Painting, Architecture,* etc.; the cultivation of these in its principles, practice, and results. (The most usual mod. sense of *art* when used simply.) 1668.

Joseph Kosuth: "*Titled (Art as Idea as Idea),*" 1967

117

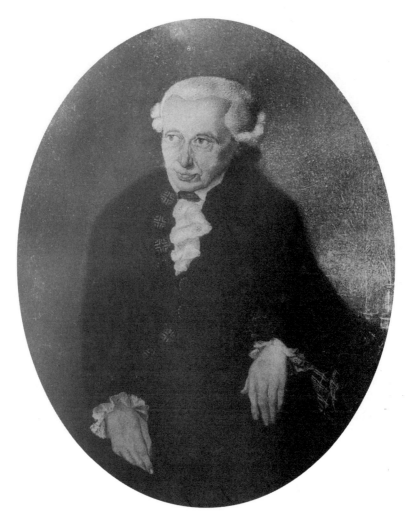

Artist unknown: Portrait of Emmanuel Kant (1724–1804)

# 4

# Aesthetics: The Theory of Art

Aesthetics—that is, the theoretical counterpart to Art—did not exist before the late eighteenth century. The philosopher Alexander Baumgarten coined the term "aesthetics" as a new science of sensuous knowledge in 1735. But it was Immanuel Kant who first delineated aesthetics, as we understand it, in his *Critique of Judgment* (1790). Kant delineated a philosophy of the beautiful when he distinguished the critical faculty of judgment from theoretical and practical knowledge.

Pure beauty, according to Kant, is found in nature and in Art. Beauty created by God is nature. Beauty created by men (and it was only men; no women were considered part of this schema) is Art. To *produce* Art one must be endowed with *genius*. To assess Art one must have *taste*. Knowledge, in this sense, is barred from Art. Kant wrote, "There is no science of the beautiful, but only a critique of it." The first property of Art is originality. Second, this originality must be exemplary. Third, Art is not governed by rules nor science. Thus a genius does not know how he creates. He is born with an inspiration to create. A spirit beyond the dictates of culture drives him to do what he does. One does not decide to be a genius. Genius is predestined.

119

A genius in the modern era is traditionally understood as someone who functions beyond the constraints of politics, patrons, and society. Leonardo or Michelangelo, for example, worked under the authority of patrons—which is radically different from the way that modern artists approach their work.

There is a story often told about one of modernity's most famous geniuses. This story may be true or it may be invented, but Pablo Picasso is said to have remembered:

> When I was a boy, my mother promised me, "If you become a sailor, you will be a captain. If you become a politician, you will be the president. If you become a priest, you will become the Pope." Well, I decided to be an artist, and I became Picasso.

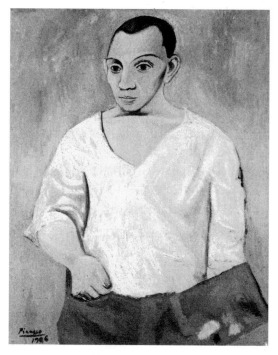

Pablo Picasso: *Self Portrait*, 1906

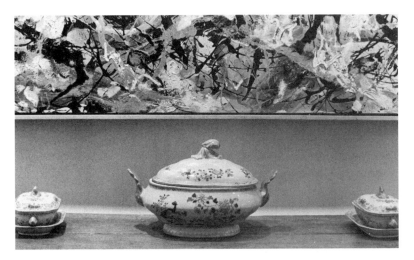

Louise Lawler: *Pollock and Tureen,* 1984–90

Similar to the way an artist's creativity flows "naturally" from its maker, taste has traditionally been understood as something that reflects a universal consensus—what Kant called *sensus communis,* or "common sense."

But today we can see that taste is not something that exists as an ideal. Taste functions as a means of distinguishing class, and it is an emblem of the way cultural criteria are legitimized.

The French theorist Pierre Bourdieu examined the workings of taste (using sociological analysis and questionnaires) in his book *Distinction: A Social Critique of the Judgment of Taste* (1979) and argued:

Taste classifies, and it classifies the classifier.

Taste is not something "natural" but something cultural, something produced. Bourdieu looked at the way the consumption of Art and culture legitimates "social differences." Having taste and appreciating fine art is a means of distinguishing yourself: It's a way of demonstrating that you have class.

121

Jenny Holzer: *Untitled* (selections from *TRUISMS*), 1979–83, text on Spectacolor Board, Times Square, New York, 1982

All of these terms—beauty, genius, taste—were used before the late eighteenth century, but they take on very specific meanings in modernity—meanings that make sense to the modern mind.

In antiquity, the Greek and Latin equivalents of the modern word beauty, καλόν and *pulchrum*, were not distinguished from the notion of moral good. Medieval or Renaissance theoretical discussions of beauty did not treat this as an autonomous quality; rather, beauty was personal beauty, moral beauty, and so on. The term genius is traditionally presumed to be a feature of Renaissance culture. But it is only with a modern notion of free will and the dissolution of the authority of the monarchy and the church does the modern notion of genius as we understand it come into acceptance.

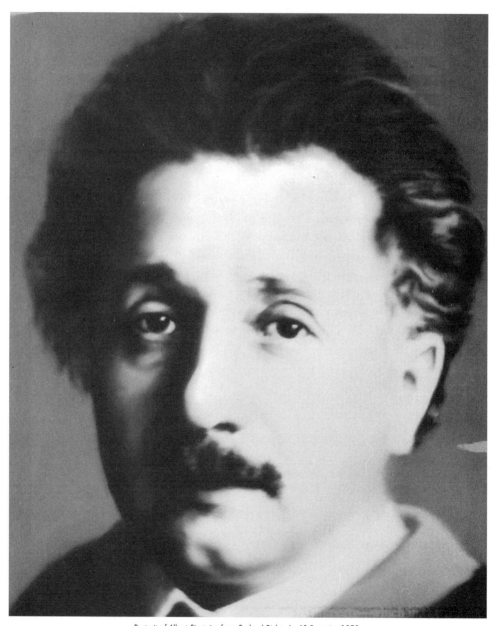

Portrait of Albert Einstein, from Gerhard Richter's *48 Portraits*, 1972

# 5

# The Privilege: Creating Art

The mythology of genius has held fast throughout modernity. We have now come to realize, however, that the concept of genius—the *natural* gift to create—is, rather, a talent developed thanks to privilege.

If genius is a natural attribute, why have there been no women geniuses? No geniuses of color? All of the geniuses in Western culture were men, and here I am looking to individuals whose extraordinary accomplishments matched their mythic statures. Think of the geniuses that come to your mind: Picasso, Beethoven, Shakespeare, Einstein.

This piece titled *48 Portraits* was created by Gerhard Richter in 1972. It consists of 48 black-and-white paintings copied from photographs of famous nineteenth- and twentieth-century men. Since the 1960s, Richter has challenged the myths of modernist painting by

questioning the tradition of the authentic brushstroke and by working with photography, and he has done this as he has continued to paint. Richter's 48 *Portraits* can be seen as a commentary on the modern mythology of genius.

The ability to do something—the power to achieve, rule, invent, and create—is founded upon an individual's belief that he or she has the right to do it. An individual must have faith in his or her ability, and then, most important, there must be access to the arenas of achievement and power.

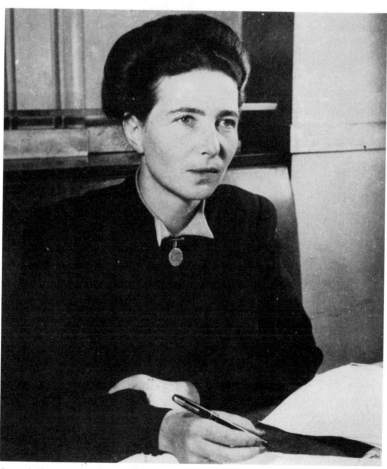

Simone de Beauvoir, author of *The Second Sex* (1949)

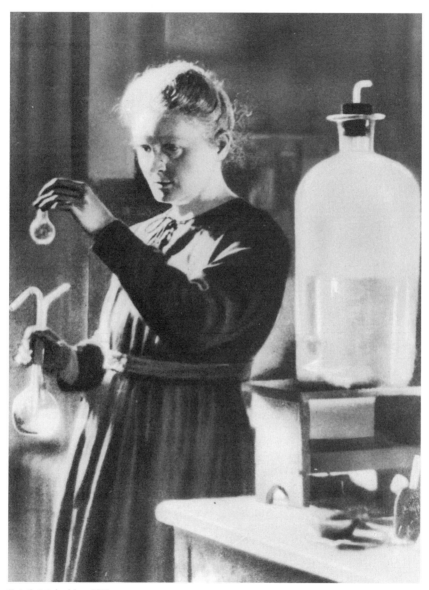

Marie Curie in her lab, c. 1920s

Until relatively recently in our culture, it was commonly believed that these rights and this power were reserved for Caucasian men.

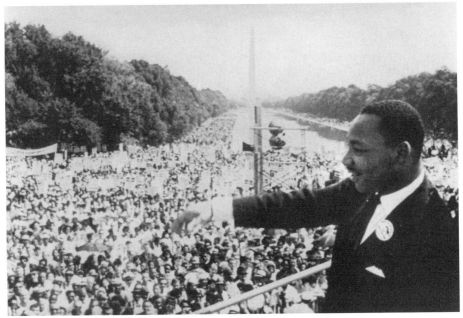

Martin Luther King, Jr., during the March on Washington, 1963

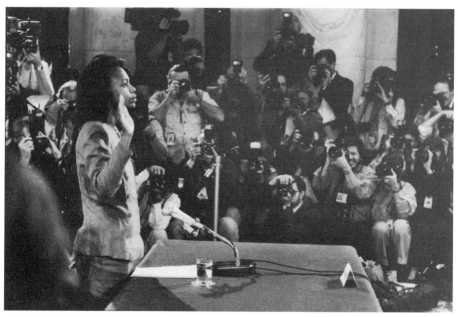

Anita Hill being sworn in to testify on sexual harassment charges against Clarence Thomas, October 11, 1991

Think, for example, about the way in which women have made history. Although much has been accomplished in terms of women's equal rights, think about a woman's ability to speak with authority and enter institutions of power.

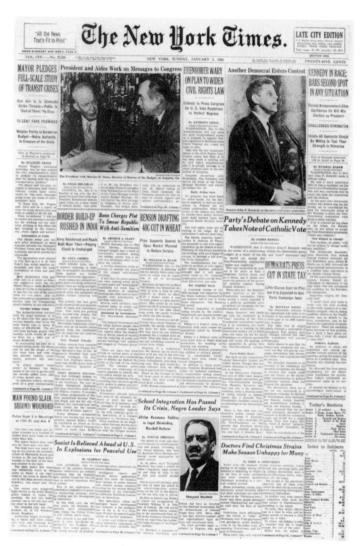

*The New York Times* January 3, 1960

Until relatively recently, men made history—and "all the news that's fit to print." Rarely did a woman's image appear on the front page of *The New York Times* in the 1960s. If a woman did appear, she was most likely a celebrity, a wife, or a mother. In the latter two categories, she was often not referred to by name. Pictures would be captioned, for example, "Sam Rayburn and the wife of Representative Hale Boggs."

132

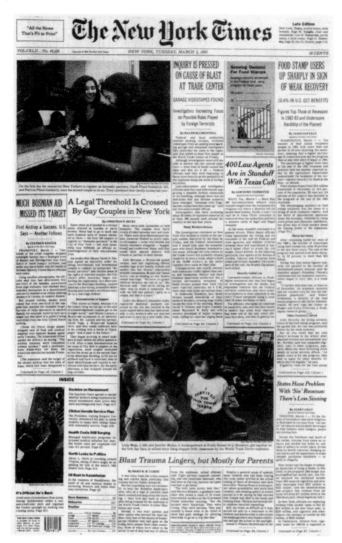

The New York Times March 2, 1993

Today women are beginning to make news, not only as celebrities, wives, and mothers—which are, of course, wonderful and important things to be—but also as attorneys general, students, professionals, and domestic partners.

One of the most widely read art history books in the United States is Gardner's *Art Through the Ages*.

The first sentence of the first chapter reads: "What Genesis is to the biblical account of the fall and redemption of man, early cave art is to the history of his intelligence, imagination, and creative power." This is followed by subchapter headings like "The Representation of Man" and discussion of "perhaps the most famous" of early female figurines, the Venus of Willendorf, in which "the artist's aim was not to show the female of his kind, but rather the idea of female fecundity; he depicted not woman, but fertility."

The use of "he"—the assumption that the artist is male—excludes half of the population from being endowed with the talent to create. When I first read Gardner and similar influential textbooks like Janson's *History of Art* some twenty years ago, I did not see that I, as a woman, was excluded from the possibility of contributing to the canon of great works by great men. I did not see that the language of these texts spoke of this exclusion in the use of the personal pronoun "he." This blindness to what is now clearly visible to me was ideology at work. I accepted patriarchal language as natural and neutral and the way things should be. This was most likely the case with Helen Gardner when she wrote *Art Through the Ages*.

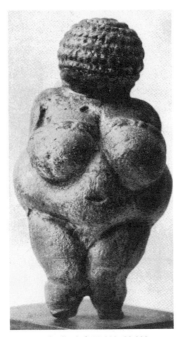

Venus of Willendorf, 25,000–20,000 B.C.

Gardner was first published in 1926 and Janson in 1962, and in the recent edition of Gardner (which is generally considered more "progressive" because there is more of an attempt to contextualize the works of Art) the editors have included a disclaimer in the preface that states that the editors and writers do not have any "prejudice" against women, nor are they trying to "disparage" women in their use of "he" for both sexes and terms like "mankind" for the human race. But Gardner is a book whose purpose is to explore the meaning and power of representation. That its editors and authors disavow the meaning and power of a thousand pages of exclusionary, patriarchal language is an unfortunate irony.

In 1971 art historian Linda Nochlin asked the question, Why have there been no great women artists? She specifically challenged the premise that "whatever is" is "natural" and argued for an examination of the institutional preconditions for achievement in the arts. She examined the fact that in the nineteenth century, "prolonged study of the nude model was essential" for the training of artists. But during the nineteenth century women artists were not permitted to work with any nude models, male or female. Nochlin wrote, "By examining . . . a single instance of deprivation or disadvantage—the unavailability of nude models to women art students—we have suggested that it was indeed *institutionally* impossible for women to achieve excellence or success on the same footing as men, *no matter what* their talent or genius." Answering her original question, she wrote: "The fault lies . . . in our institutions and our education—education understood to include everything that happens to us from the moment we enter, head first, into this world of meaningful symbols, signs, and signals."

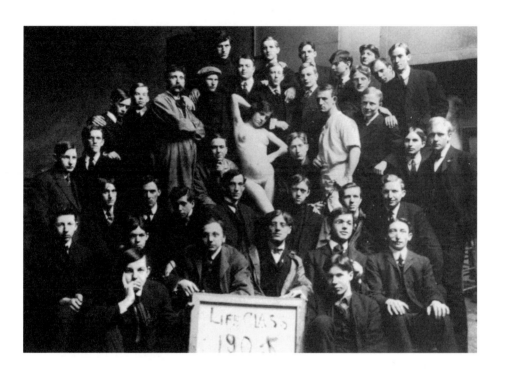

This 1905 photograph of a life class at the Art Institute of Chicago was appropriated by painter Deborah Kass as her invitation for a 1990 one-person exhibition.

Lyubov Popova: *Untitled,* c. 1916–17

There have been moments in the early twentieth century when women did attain some equality in regard to artistic production. In the Soviet Union, particularly, after the 1917 revolution, artists like Alexandra Exter, Lyubov Popova, and Varvara Stephanova produced important paintings, stage designs, graphics, and fashion. But this was more of an exception than the rule, and in the past art histories have tended to emphasize the accomplishments of their male counterparts such as Kasimir Malevich, Aleksandr Rodchenko, and Vladimir Tatlin.

138

Alexandra Exter: Costume design for *The Guardian of Energy*, 1924

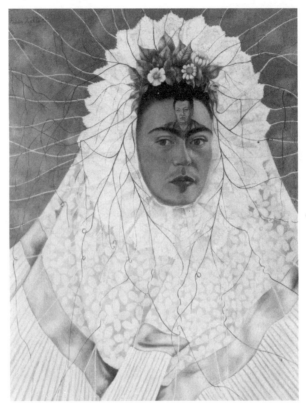

Frida Kahlo: *Self-Portrait as a Tehuana, or Thinking of Diego*, 1943

It is only gradually and relatively recently that women artists such as Frida Kahlo, Meret Oppenheim, Varvara Stephanova, Louise Bourgeois, Betye Saar, Eva Hesse, and Hanne Darboven have begun to achieve the stature and reception commensurate with that of their male colleagues. Kahlo's paintings conjure Mexican folk and popular culture, Catholic mythology, and Surrealism to create powerful images of great beauty and horror, of human frailty and strength. In the above portrait she painted herself with an image of Diego Rivera, her husband, in her third eye; Kahlo is dressed in the traditional Tehuana costume of the Tehuantepec region of Mexico, where matriarchal traditions survive to this day. Kahlo at times wore this traditional costume, as did many educated urban Mexican women in the 1920s and 1930s, as a symbol of Mexican and Indian traditions and of women's power and strength.

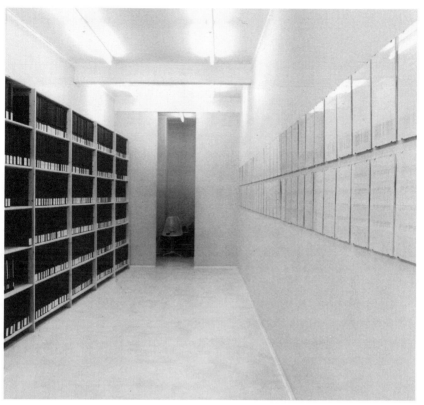

Hanne Darboven: *One Century in One Year*, 1971

Since the late 1960s Darboven has been making diary-like pieces. Her Art involves daily inscriptions using numbers and repetitive markings that follow systems she has created for herself. In her 1971 piece *One Century in One Year*, she counted in looseleaf notebooks from 0 to 99 every day for one year and then exhibited these books in a library-like installation. Darboven's pieces, composed of her daily writings and set up according to her own arbitrary systems, provide an anti-expressionist, obsessive, personal, and revealing means for marking the moments of her life.

Think of the great artworks of modernity . . .

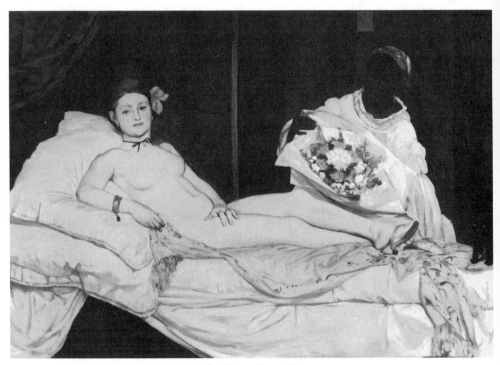

Edouard Manet: *Olympia,* 1863

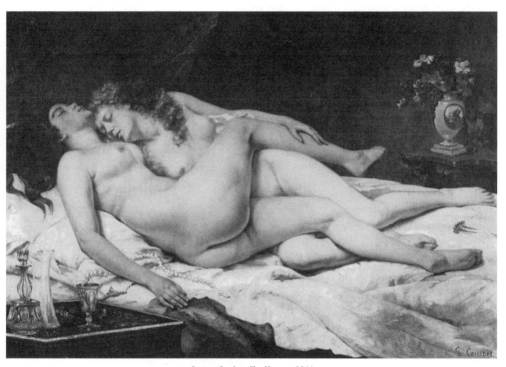

Gustave Courbet: *The Sleepers*, 1866

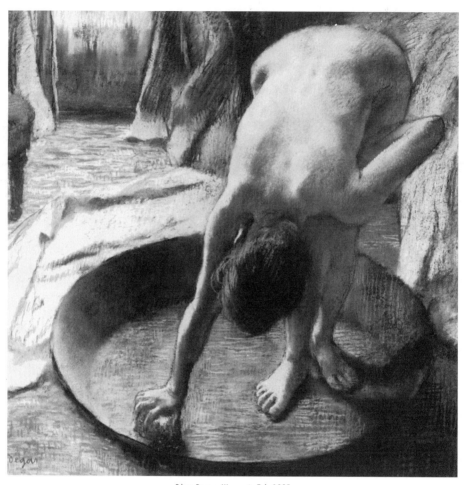

Edgar Degas: *Woman in Tub,* 1885

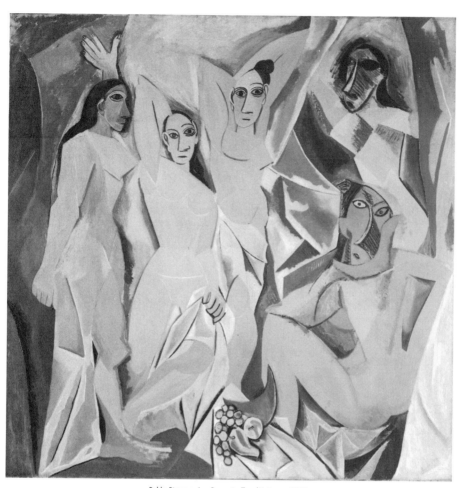

Pablo Picasso: *Les Desmoiselles d'Avignon*, 1907

145

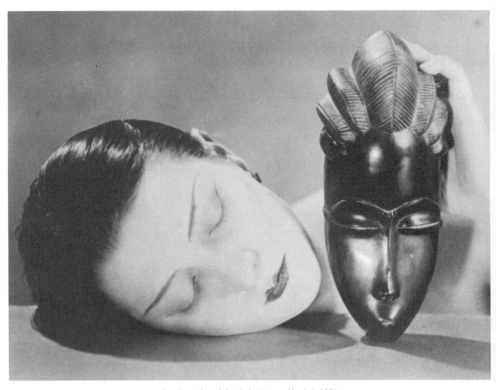

Man Ray: *Kiki and the Mask (Noire et Blanche)*, 1926

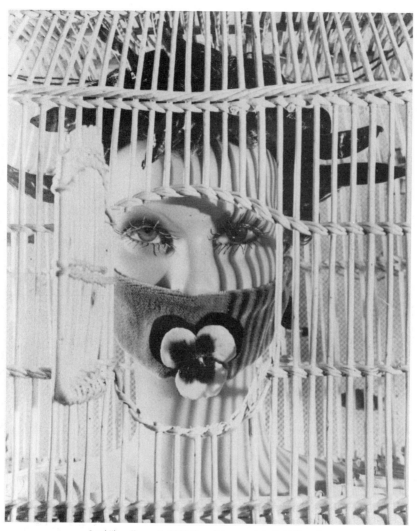

Raoul Ubac: *Mannequin*, 1938 (Surrealist mannequin by André Masson)

James Rosenquist: *Waves*, 1962

David Salle: *His Brain*, 1984

Women in the history of Art have traditionally been the objects of desire and of the gaze for what was presumed to be heterosexual male creators and audiences. To recognize this is not to diminish the accomplishment of these artworks. Nor should we be simplistic and say that because these images are of women, they should be dismissed. Rather, these images are important for many reasons, some of which involve their revelations regarding the particular historical moments of their creation. These works of Art, therefore, act as lenses of our culture, making more clearly visible what we see and what it is presumed we want to see.

(*opposite*) Piero Manzoni: *Living Sculpture*, 1961, photograph by Ugo Mulas

Barbara Kruger rephotographs images from the mass media and captions them with slogans that challenge conventional thinking:

Kruger acknowledges the other half of the audience—the half that is female.

Viewer looking at *Genre: The Conversation Piece*, an installation created by Douglas Blau at
Sperone Westwater gallery, New York City, 1993

In the early 1980s many women artists chose to address the fact that creativity has traditionally been founded upon not only talent but privilege. Many of them chose photography as their medium—perhaps because it is an alternative to the absolute domain men have had in paint. Photography is also a more obviously "mediated" medium than is painting or drawing, in the sense that it is a less direct means of expression. Photography requires a mechanical apparatus and a chemical process of producing images from a negative. A photograph has no original and exists only as a reproduction made from a negative. The mythology of modernism held that painting was the imprint of the artist's psychological life. Paint was supposed to be a spontaneous, unmediated, and—not unrelated to this—highly prized self-expression.

By definition, however, a medium—like all forms of expression and communication—is mediated.

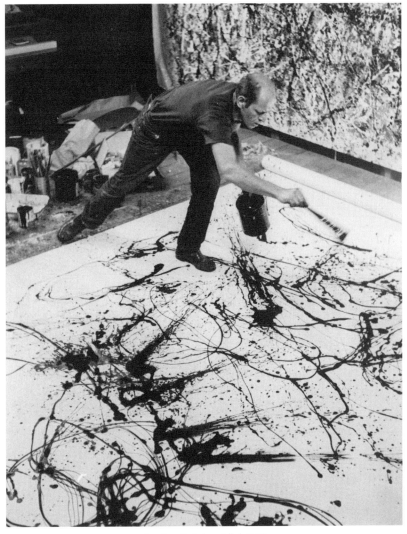

Hans Namuth: *Jackson Pollock,* 1950

In the late 1970s and early 1980s, Sherrie Levine rephotographed the masterpieces of great modern photographers. She rephotographed the work of Edward Weston, Walker Evans, and Aleksandr Rodchenko. By doing this Levine joined the ranks of important twentieth-century artists who have challenged modernist mythologies about the absolute originality of an artist's creation. But Levine is also among the women artists who have called into question men's privileged relationship to creativity and ownership in modern Western culture.

Edward Weston: *Neil, Nude,* 1925

Sherri Levine: *After Edward Weston,* 1980

She challenged men's relationship to property—which in the past often included women.

At the same time artist Cindy Sherman was creating an important series often referred to as her "film stills." For these images, Sherman photographed herself in stereotypically feminine poses and roles. She played with the convention of woman as the artist's subject, while she herself was simultaneously and self-consciously the creator.

Cindy Sherman: Untitled Film Still, 1978

Cindy Sherman: Untitled Film Still, 1979

157

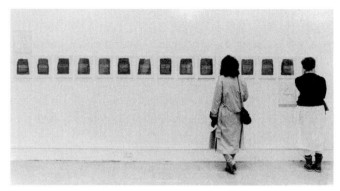

Installation of Mary Kelly's *Post-Partum Document*, 1973–79, at "The British Art Show," 1984–85, The Royal Scottish Academy, Edinburgh

Mary Kelly's conceptual art installation and book titled *Post-Partum Document* deals with the weaning of a child from his or her mother and the fact that our subjectivity is an intersubjectivity: something that comes into being between people and within culture. Kelly's piece is a landmark that critiques modern myths about subjecthood. Her work challenges predominant conceptions of the self where an individual is supposed to have an essential ahistorical nature and is presumed to be male.

The *Document* is a diary of pictures, objects, and texts that record Kelly's thoughts, her conversations, the baby's speech, his scribbling and his writing, as well as fragments of baby fetishes (bits of blanket, plaster casts of the child's hand) that are similar to the mementos parents traditionally treasure (the bronzed booties, the lock of hair). These souvenirs are organized within sections structured by the psychoanalytic theories of Jacques Lacan. (Lacan determined that access to the unconscious—for example, Freud's "talking cure"—is through language. Thus our sense of ourselves is shaped by our representations, our culture.) In Kelly's project the very intimate and personal documents of Kelly and her son's life are combined with psychoanalytic theory to explore the way our subjectivity, our conception of ourselves, is contingent upon that which is outside ourselves.

Details from Mary Kelly's *Post-Partum Document*, 1973–79

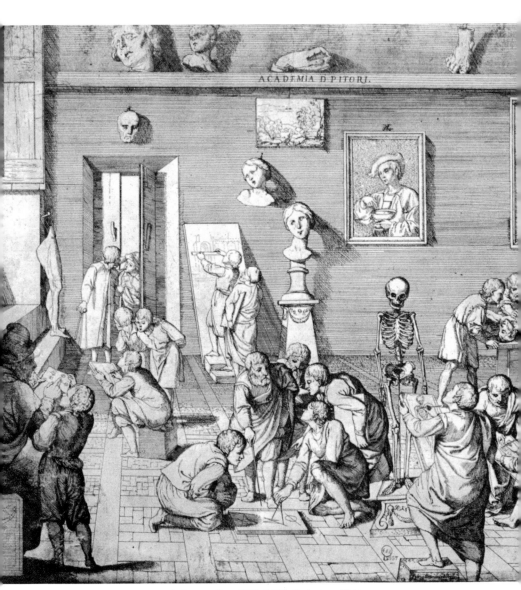

Pierfrancesco Alberti (1584–1638): *The Academy of Painters*

# 6

# The Academy

"One does not learn to make Art, one creates it."

The above is one of the myths of modern Art. From the sixteenth through the eighteenth centuries, painting and sculpture were, for the most part, taught according to rational laws and principles within the academy. At that time, there were a variety of academies that were state institutions which supported and taught the sciences and the various liberal, mechanical, and beaux arts.

The foundations for the academy were laid in 1563 when Giorgio Vasari created "La Accademia del Disegno" (The Academy of Design) under the auspices of the Grand Duke of Tuscany, Cosimo de Medici. The academy marked a new type of professional and pedagogical institution that, in many ways, took the place of the guilds

161

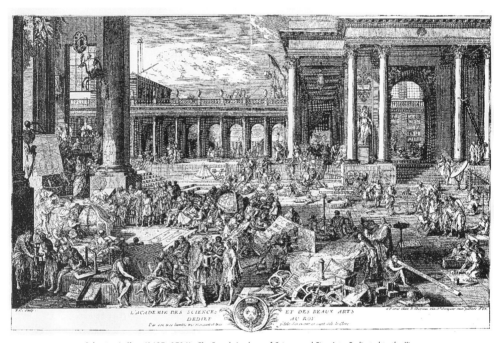

Sebastien LeClerc (1637—1714): *The French Academy of Science and Fine Arts, Dedicated to the King*

and the companies—the professional organizations for painters, sculptors, craftsmen, and architects that had existed since the Middle Ages.

The Accademia del Disegno and the Medici Court of the second half of the sixteenth century were the aesthetic and political prototypes for institutions that found their most elaborate and paradigmatic forms under the reign of Louis XIV in France, during the seventeenth and eighteenth centuries. At this time, a grand and complex system of academies was developed under the directorship of Colbert that had one primary purpose: to serve and glorify the crown. During the eighteenth century, academies were created throughout Europe, particularly in France, England, Germany, Italy, the Netherlands, and Scandinavia.

The dissolution of the monarchy and the academy began during the French Revolution, when the Republic was established and the academies were abolished. Although the academy, like the French monarchy, was quickly reestablished, this dissolution marks the beginning of the gradual shift in the teaching and patronage of Art from a monarchical and public model to an individual enterprise supported predominantly by the private sector.

It was in Germany in the early nineteenth century that a new ideal for teaching Art gained currency. The private studio and the master class, where the artist had an intimate relationship with his pupils, became the favored practice. These ideas about creativity and inspiration were nurtured within early nineteenth century Romanticism. The belief that Art was something that could be taught became suspect, as did the academy and its tenets. Although academies were still very powerful, from a broad perspective, the sovereignty and standards of the Ancien Regime were losing authority. Artists and writers like Eugène Delacroix and Johann Wolfgang von Goethe criticized academic learning. By the late nineteenth century, under the aegis of individualism, the modern notion of genius came to reign.

This is not to say that the academy and its exhibitions, the salons, disappeared. But what we have come to consider the great Art of the nineteenth century was not, for the most part, supported by academic institutions.

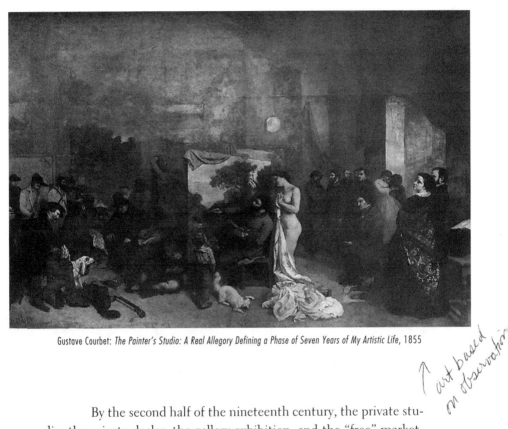

Gustave Courbet: *The Painter's Studio: A Real Allegory Defining a Phase of Seven Years of My Artistic Life*, 1855

By the second half of the nineteenth century, the private studio, the private dealer, the gallery exhibition, and the "free" marketplace began to supercede the monarchical institutions of pedagogy, patronage, and prestige. In midcentury France, for example, Gustave Courbet set up his own pavilion to show his paintings outside the government-sponsored Universal Exposition. In 1867 Edouard Manet followed suit. By the end of the century it was commonplace for artists to disdain the academy and all that it stood for. Paul Gauguin wrote of the "bondage" of the academy. Paul Cézanne believed that an artist could only learn from nature and stated that "institutions, pensions, and honors can only be made for cretins, rogues, and rascals." And James McNeill Whistler denounced "The academy! Whom the Gods wish to make ridiculous, they make academicians."

F. T. Marinetti (center) wearing Futurist vest designed by Fortunato Depero (left), c. 1920s

Virgilio Marchi, "Manifesto of Futurist Architecture" on front page of
*Roma Futurista*, February 29, 1920

By the beginning of the twentieth century, most of the artists
we remember today as important or significant would agree with what
F. T. Marinetti printed on the front page of the French newspaper *Le
Figaro* in 1909:

> In truth I tell you that the daily round of museums,
> libraries, and academies (cemeteries of vain efforts,
> calvaries of crucified dreams, registries of aborted be-
> ginnings!) is as damaging for artists as the prolonged
> guardianship of parents is for certain young people
> drunk with their talent and ambitious desire. . . . We
> want no part of it, we are young and strong *Futurists*!

Magazine store in New York City, 1993

By the late nineteenth century, the modern dealer-critic system had replaced the academy and its salons. But what must be kept in mind is that this new system is one of private enterprise, where the individual has to release his or her work into the institutions of reception—the galleries, the critics, the publications, the private collections, the museums, the mass media—where the work acquires its meaning and value.

Jeanette Ingberman and Papo Colo installing the 1993 exhibition "Poverty Pop" at Exit Art in New York City

Metropolitan Museum, New York City, 1993

# 7

## The Museum

In the late eighteenth and early nineteenth centuries we find the foundations of the museum as we know them.

Although universities, the church, and the aristocracy have collected paintings and statues throughout Western civilization, these collections were very different from the modern museum collection.

In the sixteenth and seventeenth centuries, European scholars and nobility created *Wunderkammen* or *Kunstkammen*, which contained all kinds of natural curiosities and specimens, scientific instruments, exotic treasures, books, objects of everyday life, coins, and globes, as well as paintings and statues. The Archduke Ferdinand of Tyrol (1520–1595) had such a collection in his castle at Ambras,

where there were mosaics composed of hummingbirds' wings, a male and female mandrake on a bed of blue taffeta, and carved cherry pits, as well as portraits by court painter Francesco Terzio. From the ceiling of his gallery hung stuffed serpents, crocodiles, birds, and the bones of prehistoric animals.

During the seventeenth century in Milan, Manfredo Settala put together a collection that contained microscopes, telescopes, stuffed animals, bone specimens, natural curiosities, antiques, books, paintings, and sculptures.

Manfredo Settala's *Cabinet of Curiosities*, in Milan, from Paolo Maria Terzago's *Museo o Galeria: adunta dal sapere, e dallo studio del sig. Canonico Manfredo Settala*, 1666 edition

One of the greatest collections of the seventeenth century was that of Emperor Rudolf II in Prague. Emperor Rudolf's *Kunstkammer* included a mammoth's tusk, fossils, shells, mirrors, lenses, Turkish and Hungarian horse harnesses, landscapes by Albrecht Dürer and Pieter Brueghel the Elder, and drawings and prints from Italy. The emperor commissioned many still-life paintings by Giuseppe Arcimboldo. There were hippopotamus teeth, automatons, and even a "fine veil, which had fallen miraculously from the sky into the camp of His Majesty in Hungary." Scholars have noted that the logic of these collections is impenetrable to the modern mind. For example, one cupboard would have statues, the next would have shells, another would be filled with objects from India.

The meaning of the collections followed an order different from that of our own. The list of objects in the emperor's collection is reminiscent of a famous passage from Michel Foucault's important book *Les Mots et les chose* (*The Order of Things*), first published in 1966.

Foucault cited a passage from a novel by Jorge Luis Borges describing an entry in a "certain Chinese encyclopedia":

> ... "animals are divided into: (a) belonging to the Emperor, (b) embalmed, (c) tame, (d) sucking pigs, (e) sirens, (f) fabulous, (g) stray dogs, (h) included in the present classification, (i) frenzied, (j) innumerable, (k) drawn with a fine camelhair brush, (l) *et cetera*, (m) having just broken the water pitcher, (n) that from a long way off look like flies," ...

And Foucault went on to write: "In the wonderment of this taxonomy, the thing we apprehend in one great leap, the thing that, by means of the fable, is demonstrated as the exotic charm of another system of thought, is the limitation of our own, the stark impossibility of thinking *that*."

Foucault was writing about the impossibility of our understanding the logic of this Chinese encyclopedia. Foucault saw his work as an "archaeology of knowledge," which might be described as an examination of the orders that remain, in a sense, unconscious and that structure the thought and the life of specific periods. Foucault mapped out several great periods in the West during the last 500 years. He described the beginning of a new order of things at the end of the eighteenth century and the beginning of the nineteenth—what I have outlined in this book as "the modern."

Foucault's book is about the limitations of the way we see and know ourselves and the world. It is impossible for us to fathom the reasoning behind this Chinese encyclopedia entry, as it is impossible for modern scholars to apprehend the way the Emperor Rudolf saw and understood his collection.

In modernity, we live with a particular but ever-changing social order that structures our institutions, our conceptions of ourselves, even the way we arrange objects around us. Different from the collections of the sixteenth and seventeenth centuries, in modernity

we have public museums reserved solely for works of Art. A paradigm for the modern museum is the Altes Museum in Berlin, constructed from 1822 to 1830.

This was an institution for the exhibition and preservation of objects possessing aesthetic beauty. This was the beginning of the museum as we now understand it. The Altes Museum was not a place for practical study nor facile diversion, it was a preserve for high Art.

Karl Friedrich Schinkel: Altes Museum, Berlin, 1822–30

Before the late eighteenth century, there were, of course, picture and statue galleries. Like a *Wunderkammer*, however, their function was different from that of the modern commercial or nonprofit gallery. Paintings, for example, were stacked, filling the entire gallery. Their function was to create a lively decorative scheme.

This image shows a painting being cut to fit the dimensions of a room, a practice common in the eighteenth century.

Daniel Nicolas Chodowiecki: *The Art Lovers,* c. 1770

The convention of hanging a single painting at eye-level on a pure white wall is relatively new and was institutionalized in the 1930s. This is the way Kasimir Malevich installed his abstract paintings in Russia at the famous "O.10. The Last Futurist Exhibition" in 1915:

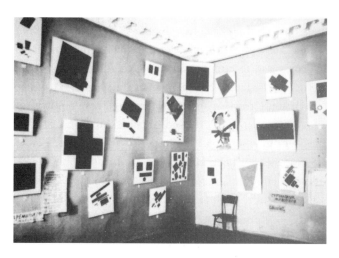

This is the way Alfred Barr, the founding director of the Museum of Modern Art, installed MoMA's first exhibition, "Cezanne, Gauguin, Seurat, and van Gogh," in 1929:

In the 1980s there were changes in the way we view and appreciate works of Art as we entered the age of the postmodern museum. Museums are no longer institutions devoted solely to the display and appreciation of aesthetic masterworks, as was the case with Schinkel's Altes Museum. Compare the neo-classical facade of the Altes Museum with the Metropolitan Museum's neo-classical facade draped with billboard-like banners for corporate-sponsored blockbusters. Museums like the Met are now composed of giftshops and bookstores and restaurants and bars, in addition to their exhibition galleries. In the late 1980s many museums began setting up reading rooms in some of the galleries so that visitors could rest or read the catalog and other books related to the exhibitions. Study collections also became more prevalent in the 1980s. These collections would previously have been kept in storage but are now publicly displayed in nonhierarchic cases and storage racks. This is not to say that some of these aspects of the postmodern museum did not exist in the modern museum, but what has changed is their predominance and variety. The next time you are in a museum, compare the time you spend eating, shopping, reading, and socializing with the time you spend contemplating Art.

Exterior of Museum Design Store of the Museum of Modern Art, New York City, 1993

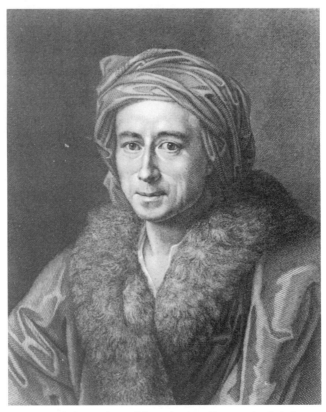

Portrait of Johann Joachim Winckelmann, the engraved frontispiece from his book
*The History of the Art of Antiquity*, 1764

# 8

## The Discipline: Art History and the Development of Modernism

Like museums, galleries, aesthetics, and the term Art, art history is an invention of modernity.

In 1764 Johann Joachim Winckelmann published *The History of the Art of Antiquity*. This book laid the foundations for the discipline of art history and served as the most influential model for writing about Art. What was important about Winckelmann's contribution is that he wrote about Art in terms of style.

Winckelmann chronologically classified Greek and Roman Art into a sequence of periods in which there was an origin, a development, and a decline: the Greek archaic style, the early classical style, the late classical style, and Roman imitation and decay.

Before Winckelmann, histories of painting and sculpture

were collections of artists' lives. (The exception to this was the introduction to the three sections of Giorgio Vasari's famous "Lives of the Artists," 1550—which is a collection of individual biographies. The introduction, however, presents the work of Italian artists as a development and refinement of earlier painting and sculpture and can be seen as a prototype of the modern model.) Winckelmann's history describes different periods and their painting and sculpture as an organic and logical development of the essence of Art.

Particularly interesting with regard to the institutions of modernity was the reception of Winckelmann's ideas. When the book was first published in 1764, it was received primarily as a source of information about the antique. But later, in the 1790s and early 1800s, Winckelmann's text became appreciated as a method for writing history.

Winckelmann's book is a landmark in early modern history in that the past is organized in terms of growth and decline. It has been suggested that his history of style served as a model for pragmatic histories, like those of Leopold von Ranke and Edward Gibbon. In a certain sense, history—as we understand it—was invented in modernity. In the nineteenth century it was "modern" to see civilizations as having a linear growth that progresses and declines and is connected through time.

Early modern Art is a magnificent representation of this organic, progressive, self-reflective order that structures early modern disciplines. The story of modern Art, until the beginning of the twentieth century, is one of gradual development, from realistic, illusionistic representations to more abstract, "ideal" images.

Think about what you know about modern Art.

Caspar David Friedrich: *Landscape in the Riesengebirge (Giant Mountains) with Foggy Valley,* c. 1812

Claude Monet: *View of Argenteuil, Snow,* 1874–75

Paul Cézanne: *Mont Sainte-Victoire Seen from Les Lauves,* 1902–1906

Piet Mondrian: *Composition in Red, Yellow & Blue,* 1930

A similar linear evolution is found in the stylistic development of the great masters of modernism. The work of Piet Mondrian is one example.

Piet Mondrian: *Trees Near Gien*, 1908

Piet Mondrian: *Tree*, 1912

Piet Mondrian: *Pier and Ocean*, 1914

Piet Mondrian: *Composition in Red, Yellow & Blue*, 1930

Early modern Art had a very clear development. Both form and content, in a sense, progressed to their essential and most ideal manifestations. For example, painting was seen as reaching its "essence" in the middle of the second decade, when artists began to paint abstractly.

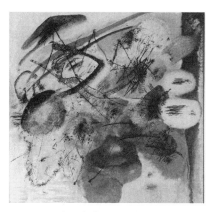

Wassily Kandinsky: *Composition,* 1913

This is a Wassily Kandinsky *Composition* from 1913.

Kasimir Malevich: *The Black Square,* 1915

This is Kasimir Malevich's *The Black Square,* which he painted in 1915.

Mondrian believed that by reducing his painting to verticals and horizontals and the three primary colors—red, yellow, blue—as well as black and white, he had reduced the components of painting to the essence of the visual. Like Malevich and Kandinsky, Mondrian believed that his abstract Art was a unique and universal language for the modern world.

Piet Mondrian: *Composition in Red, Yellow & Blue,* 1930

Many abstract painters went so far as to believe that the purity, the perfection, the harmony, and the balance of abstract Art would move viewers so profoundly that these paintings would provide metaphysical solace for the modern world.

Frontispiece of Wassily Kandinsky's *Über das Geistige in der Kunst (Concerning the Spiritual in Art)*, 1912 (actually published in December 1911)

In his book *Concerning the Spiritual in Art*, Kandinsky describes his ideas about the universal spirit of an age, which is what he tried to represent in his abstract painting.

But there is great irony to early twentieth-century abstract Art. While these creations were attempts to paint the essence of the visual and to represent a metaphysical reality that could be seen only in painted form, they are simultaneously representations of the limitations of abstraction—and, in a sense, of making Art. Abstraction makes visible that painting is merely paint on canvas. This is one of the profound contradictions of early twentieth-century abstract Art.

Kasimir Malevich: *The Black Square*, 1915

Many artists at that time recognized this irony and wanted Art to confront the questions and absurdities of modern life more immediately and more directly. Their concerns were no doubt spurred by the fact that Europe was suffering through the chaos of WW I, and this led the Dadaists to experiment with their creative options. In Germany in 1918, the last year of the war, Dadaist Richard Huelsenbeck in a Dada speech exclaimed:

> Has Expressionism fulfilled our expectations of such art, which should be an expression of our most vital concerns?
>
> No! No! No!
>
> Have expressionists fulfilled our expectations of an art that burns the essence of life in our flesh?
>
> No! No! No!

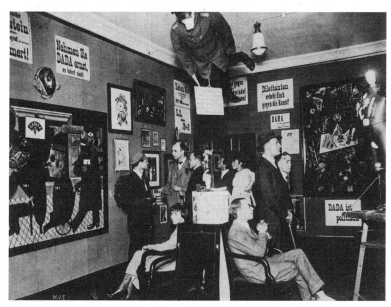

The Berlin Dada Fair at the Burchard Gallery in June 1920.

Frank Stella: *Island no. 10*, 1961

This contradiction is something many abstract artists later in the twentieth century have addressed and continue to address in their work. For example, when Frank Stella made his black paintings in the 1960s, he said he didn't want his painting to be like "handwriting," like "Abstract Expressionism"; he wanted to "keep the paint as good as it was in the can."

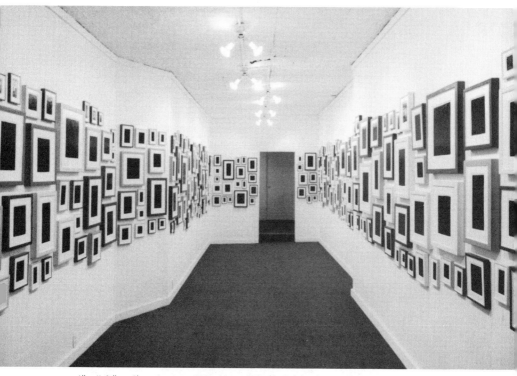

Allan McCollum: *Plaster Surrogates*, 1982–84, installed at the Cash/Newhouse Gallery in New York, 1985

These are the "surrogate paintings" produced by Allan McCollum in 1983. They are plaster casts that are produced in batches and then painted to look like abstract pictures and frames. What kinds of questions does this work raise regarding the originality of creation and the meaning of Art?

In the twentieth century, the early modern notion of progress and development breaks down, and we see a visualization of this breakdown in twentieth-century Art: Artists repeat themselves, they recycle previous styles, they create series, they produce multiples. Linear development and "originality" disappear. (craft?)

Kasimir Malevich: *The Black Square,* 1915          Ad Reinhardt: *Abstract Painting,* 1960–66          Allan McCollum: *Surrogate Painting,* 1978–8

In the early twentieth century, abstract artists were idealistic and utopian. They eschewed pictures of things, stories, references to nationality, and history in an attempt to create a universal language for the modern world.

But the silence of these ideal images, the purity of these forms, did not essentially and absolutely represent a metaphysical realm. Instead, abstraction made visible the materials of which Art was made.

Rather than being a universal language for the modern world, abstract Art was—and remains today—an arcane, esoteric subject that is understood and appreciated by an informed few. This has been called the failure of modernism and the failure of abstract Art.

This is a relief to me as an "uninformed" It isn't that I just don't get it

As it turns out, it is modern Art's Other—popular culture—
that is the universal language of modernity.

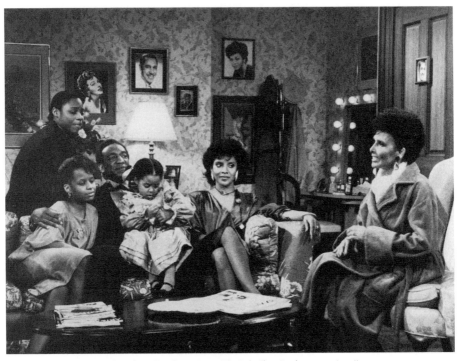

Image from the 1980s television series "The Cosby Show," with guest star Lena Horne

This is not to diminish the beauty and accomplishment of a Mondrian. Although abstract painting did not provide metaphysical salvation for the modern world, this Art was painted with such conviction and such faith that sometimes—when I look at a Mondrian (like this one, which hangs in the Museum of Modern Art) and I see the simplicity of forms, the perfect sense of balance, the brilliant distillation of the composition—I think, perhaps, that Mondrian, in many ways, may have been right. . . .

Piet Mondrian: *Painting I*, 1926

But what Mondrian intended for his Art was not to be. The Coca-Cola trademark—not the Mondrian painting—is a universal symbol for the modern world.

Piet Mondrian: *Painting I,* 1926

Everyone—in a suburb of New Jersey, in a village on the Amazon, or in the middle of downtown Tokyo—recognizes and, in a sense, wants to drink Coke.

Video still from a Coca-Cola television commercial that aired during the 1992 Olympics

But how many people in New Jersey or from the Amazon rain forest have seen a Mondrian composition from the 1920s?

Coke advertisement in Seoul, Korea, 1988, photograph by Neil D. Sampson

Tourists and visitors at the Metropolitan Museum of Art, New York City, 1993

# 9

## The Avant-Garde, Popular Culture, and the Creation of the Mass Media

Art is, of course, just one aspect of the modern social fabric that developed during the nineteenth century. Art can be understood as a domain shaped by what has been called "the great divide" of modern visual culture, which separates Art from popular culture. Art and popular culture share the same historical berth; each defines the other, while this "great divide" remains permeable and ever changing.

The commercial counterpart of the gallery and museum is the boutique and department store. All of these institutions develop in the nineteenth century.

The Fine Art, China, and Silver Room at Macy's Department Store, 14th Street location, 1883

Exhibition design and commercial display techniques share an overlapping history. Looking at things on public display is one of the myriad leisure-time activities the modern citizen enjoys. (Leisure time—dividing one's life into weekdays and weekends—is a development of modernity. To generalize broadly, in premodern Europe, for example, if you were an aristocrat your life was primarily leisure, but if you were a servant, with the exception of religious days of rest or traditional festivals, you worked all the time.) The modern pastimes of window-shopping and visiting art galleries are, in a sense, different sides of the same coin.

Allan McCollum: *Fifty Perfect Vehicles*, 1985–89, installed at the Stedelijk Van Abbemuseum in Eindhoven, 1989

Below is Karl Friedrich Schinkel's design for a *Kaufhaus*, a bazaar composed of many small shops, which was never built. This imagined *Kaufhaus* can be seen as a precursor to what later in the century would become the department store. Schinkel's design for this grand gallery of shops looks somewhat similar to that of the Altes Museum, begun in 1822 and completed in 1830.

Karl Friedrich Schinkel: *Kaufhaus*, 1827

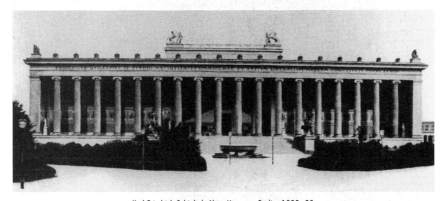

Karl Friedrich Schinkel: Altes Museum, Berlin, 1822–30.

This is not a department store; it is a 1952 "Good Design" exhibition at the Museum of Modern Art.

During the eighteenth century in the West, high culture was the privilege of the aristocracy. What we consider fine art is analogous to the props and the background for the life of the court. What we consider popular culture is similar to folk traditions—crafts, poetry, song. The aristocratic heritage and the folk traditions were preserved from one generation to the next. In modernity, the Industrial Revolution and new technologies such as photography, film, radio, computers, and television have helped to create a popular culture that is not restricted to a specific class or region. Popular culture in the twentieth century has become international. Modern popular culture is always subject to change and provides a continuous stream of new products for expanding markets and audiences. Novelty is prized in popular culture, as originality has been a criterion of modern Art.

(*opposite*) Andy Warhol amid *Brillo Box* sculpture at the Staple Gallery, New York, 1964, photograph by Fred W. McDarrah. (*below*) Andy Warhol: *Brillo Box* (detail), 1964

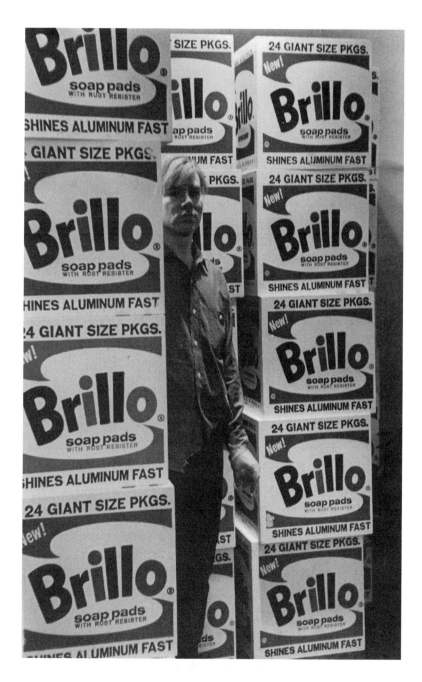

Early twentieth-century Art needs to be understood in relation to the development of the mass media as we know it. During the first half of the century, artists wanted to use the new technologies associated with mass production—photography, advanced graphic and printing techniques, radio, and film—to create a radically new and better modern world. This interest in a "New Age" and a revolutionary cultural transformation was not unrelated to the development of abstraction.

Around 1913, at the very moment that many artists were experimenting with abstraction, others began to see the cultural contingency of Art—that is to say, they began to see the institutional limitations of Art. Artists literally began to look beyond the limits of a painting's frame.

Georges Braque and Pablo Picasso's paintings were almost identical during 1911 and 1912. They were working in what is perhaps the most famous of all modern Art styles, Cubism. But by sharing in the creation of the new "style" of Cubism, Braque and Picasso called into question the validity of style. By painting almost identical paintings, they challenged the single most important criterion for judging an artistic contribution: the ability of the individual artist to invent a unique, original, and "signature" style. In their Cubist paintings, Braque and Picasso dismantled the absolute authority an artistic genius has over his style and called into question the viability of the early modern mythology surrounding creativity. The collaborative "Analytic Cubism" project of Braque and Picasso can be understood as an acknowledgment that the way we understand ourselves and the world and the way we represent and communicate this—in its most individualistic and celebrated form, "creativity"—is dependent upon things that exist outside of the self.

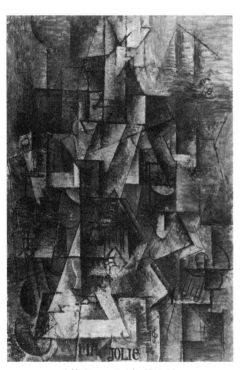

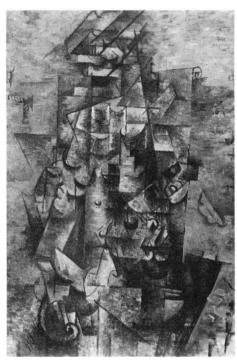

Pablo Picasso: *Ma Jolie*, 1911–12          Georges Braque: *Man with a Guitar*, 1911–12

Braque in Picasso's studio, wearing his military reserve uniform, c. 1911, photograph by Picasso

Picasso in his studio, wearing Braque's military reserve uniform, c. 1911, photograph by Braque

The "Analytic Cubism" project can also be understood as the precursor to Picasso and Braque's greatest contribution.

Contrary to the popular view of modern Art, Picasso's great contribution was not Cubism but collage. In May 1912 Picasso made the first collage by putting some oilcloth printed with a pattern of chair caning on an oval canvas and encircling the picture with rope.

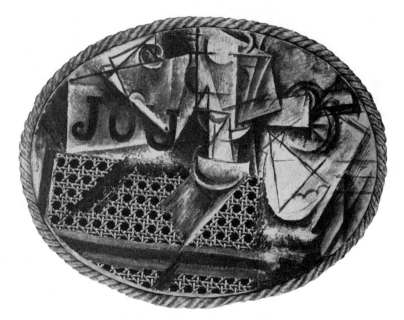

Pablo Picasso: *Still Life with Chair Caning*, 1912

Picasso then took a summer vacation. In August Braque began putting wallpaper fragments in his drawings and paintings—which Picasso saw when he visited Braque. When Picasso returned to Paris in September, he began producing collages by pasting newspaper, wallpaper, and scraps of mass-produced graphics on his paintings and drawings. For the next few years these two artists explored the possibilities and implications of this new working method.

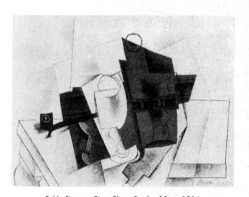

Pablo Picasso: *Pipe, Glass, Bottle of Rum*, 1914

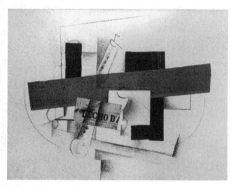

Georges Braque: *Still Life with Tenora*, 1913

Collage marked a momentous break in the tradition of Western painting. The organic integrity of oil and canvas was disrupted by the incorporation of mass-produced materials, and the sanctity of pure painting was destroyed. This (1) broke down the barriers between the autonomous, aestheticized space of painting and popular culture and (2) made visible the "phallacy" of an artist's autonomous and absolute relation to creativity.

By using these mass-produced elements, Braque and Picasso relinquished some of the artist's traditional relationship to his or her creations. To make their collages Braque and Picasso had to use elements that they themselves had not produced, and in this way they acknowledged that artists' ability to create is dependent upon that which is outside of themselves—the codes and languages of their culture.

Picasso's work that followed his collages can be understood as an elaborate investigation of the ideology of style, where the criterion of artistic achievement is the development of an absolutely original style—a unique, creative "signature."

For the rest of his life Picasso produced work that demonstrated a fantastic diversity of styles. He would work on different styles simultaneously. He would return and re-evaluate styles he had previously created. These sixty years of work can, in a sense, be seen as one project. Picasso's lifelong analysis of style can be understood as an examination of subjectivity in modernity. His oeuvre is a magnificent visual critique of a conception of the self in which an individual is believed to possess an ahistorical nature that is the source of identity—and creativity. And it is wonderfully ironic that the oeuvre of the most famous of modern artistic geniuses can be seen as a massive, lifelong dismantling of the myth of genius.

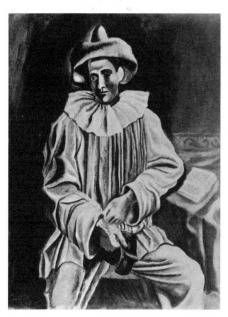

Pablo Picasso: *Pierrot*, 1918

Pablo Picasso: *Harlequin with Violin*
*("Si Tu Veux")*, 1918  .

Both of these paintings were created in 1918.

Pablo Picasso: *Women Running on the Beach*, 1922

Picasso in 1922.

Pablo Picasso: *Guitar*, 1926

In 1926.

Pablo Picasso: *Girl Before a Mirror*, 1932

In 1932.

215

Pablo Picasso: *Head of a Bull*, 1943

In 1943

Pablo Picasso: *Jug*, 1954

In 1954.

Pablo Picasso: *The Bathers*, 1956

In 1956.

Pablo Picasso: *Composition*, 1970

And in 1970.

While Picasso and Braque were making their collages, Marcel Duchamp had begun making his readymades.

In 1913 Duchamp made his first readymade, the *Bicycle Wheel*. By putting together two mass-produced objects—a wheel and a stool—Duchamp, like Picasso and Braque, acknowledged that creating something is dependent upon ways of seeing and knowing that are outside oneself. Duchamp put this bicycle wheel and stool together in much the same way we put together two words to make a sentence: "Nice picture."

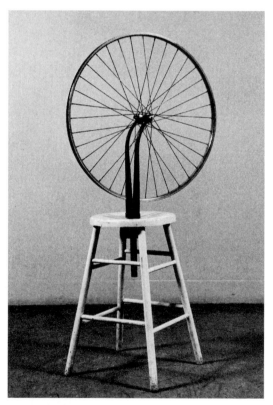

Marcel Duchamp: *Bicycle Wheel*, 1951 version after 1913 original

Collages and readymades are testimonials to the fact that all forms of representation—whether they be pictures or words or gestures—are dependent upon cultural languages. In a profound and fundamental way, these artworks by Picasso, Braque, and Duchamp make a case for the idea that what we know and represent is not something natural but cultural, and it does not exist as an ideal essence but is shaped by history.

Indebted to the discoveries of Picasso, Braque, and Duchamp, artists continue to explore the ways we create meaning. Laurie Anderson in her 1979 performance piece *Americans on the Move* played with the idea that our context and use of representations determine their meaning. In the section "Song for the Night Driver #3," Anderson says:

> . . . "Excuse me, can you tell me where I am?"
> *You can read the signs. You've been on this*
> *road before. Do you want to go home?*
> Hello, excuse me, can you tell me where I am?

Laurie Anderson performing *Americans on the Move*, 1979

> *You can read the sign language. In our country,*
> *good-bye looks just like hello. This is the way we say*
> *hello. Say hello . . .*

As an image of the Apollo 10 diagram of a man and a woman
is projected, Anderson continues:

> *In our country, we send the pictures of our sign*
> *language into space. They are speaking our sign lan-*
> *guage in these pictures. . . . In our country good-bye looks*
> *just like hello. Say hello.*

Today we would take the implications of Picasso, Braque, and Duchamp's work further. Not only is what we think, say, do, or know shaped by a particular historical moment and culture, but our representations, the way we communicate, are bound to a particular voice—which has a gender, a race, a nationality, a sexual identity, a very personal memory, a collective memory, and a history as well.

The theorist and filmmaker Trinh T. Minh-ha, for example, questions "who is writing?" "who is creating?" Her work demonstrates that we can no longer turn what she calls a "blind eye" to the historical and personal specificity of the human subject. In her 1989 film *Surname Viet, Given Name Nam,* she weaves traditional Vietnamese dance, mythology, and folk poetry with the recollections of women from both North and South Vietnam. The film's diverse visual and verbal sources, combined with the women's particular histories and memories of the Vietnam conflict, create fluid, multivalent "voices" that speak a very different history than the traditional patriarchal one.

Images from Trinh T. Minh-ha's *Surname Viet, Given Name Nam*, 1989

When artists such as Picasso, Braque, and Duchamp began creating collages and readymades, their materials manifested the radical re-evaluation these individuals were exploring in regard to their conceptions of themselves and their work. For example, there is something natural and organic about painting. It is a matrix of oil-based pigments on canvas, which is usually hemp, cotton, or linen. There is a unity to the materials, a natural, organic quality that is very different from the appropriated and mass-produced elements of a collage or a readymade.

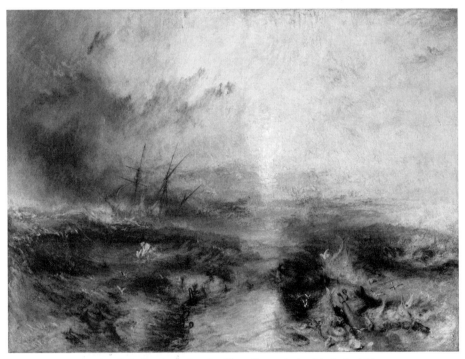

Joseph Mallord William Turner: *Slave Ship (Slavers Throwing Overboard the Dead and Dying, Typhoon Coming On)*, 1839

The traditions and mythologies related to an artist's mastery of the strokes of paint on the canvas is a metaphor for the artist's mastery of the absolute and individual domain of creation (which is not unrelated to the way white, heterosexual, Western men were led to think about themselves in relation to their world). Painting sets up a very different relationship to creativity than does collage. In a sense, Picasso gave up a little bit of the myth of an artist's power over his creation and, in a broader sense, modern man's relationship to his world. However, by acknowledging the limitations of an artist's practice, Picasso, Braque, and Duchamp gained more knowledge and power about themselves, their work, and their world in their examination of the way meaning and value are created in Western culture.

While Picasso and Braque were making their collages and while Duchamp was making his readymades, Ferdinand de Saussure's *Course in General Linguistics* (1916) was published.

Saussure's important contribution was to recognize that language is not something "natural" in the sense that words have an intrinsic relation to their meanings. Meaning is created through convention. It is tethered to a specific context, community, and history. Saussure argued that language is an arbitrary social construct.

Thus in both visual and verbal culture during the second decade of this century, there were individuals demonstrating that our representations do not belong to an unchanging, natural order. Instead they are conventions, shaped by a particular moment with a particular history.

In many fields at the beginning of the twentieth century, there were similar re-evaluations of the way meaning and value are produced. The phenomena of the world were understood as part of ever-changing histories, rather than as shadows of timeless essences. This was the case in music, in literature, in psychology, in science. The parameters of this subject are vast. But to cite one of a myriad examples, these were the years that Albert Einstein was formulating his theory of relativity.

The kinds of problems that Picasso, Braque, and Duchamp were exploring had widespread currency throughout artistic communities in the West.

As artists at the beginning of the twentieth century began producing abstract Art, they found that abstraction was not an aesthetic and metaphysical salve for the modern world. These were the years when Europe, the U.S., and Japan were fighting World War I and, amid social and political crisis, artists were re-evaluating their role in society. Artists wanted to destroy traditional notions about fine art and they began to question the institutional frameworks of Art. They believed that the criteria and practices associated with Art should be changed. Many artists began to think that the best way to revitalize culture and modern society was to creatively integrate Art into everyday life.

These artists formed groups that are often referred to as the international avant-garde. Among these groups (whose affiliations were often interwoven and ever changing) were the Futurists, the Expressionists, the Dadaists, the Surrealists, the De Stijl group, the artists at the Bauhaus, and those working within Soviet institutions. From the teens through the thirties, in different countries and in myriad ways, artists with different agendas and diverse political associations strove to revolutionize Art and, in many cases, everyday life. Many saw their work as an instrument of social change. These artists continued to make paintings and sculpture, but they also produced magazines and books, held exhibitions, shot films and photographs, designed new kinds of buildings, products, typography, graphics, and clothing, and they wrote manifestos.

The Italian Futurists thought that the new Art for the modern world should exploit the possibilities of modern technologies. They glorified industry, the military, and machines. They were politically fascist and were particularly concerned that their Art reach a mass audience. The Futurists used the popular press as a vehicle for their ideas. F. T. Marinetti published the first Futurist manifesto in February 1909 in the Parisian newspaper *Le Figaro*. In July of that year, the Futurists threw 800,000 copies of another manifesto from the Clocktower in Venice onto the crowds below. In 1920 Marinetti broadcast his poetry on a new invention, the radio. The Futurists wrote manifestos suggesting cultural revolutions for all spheres of Art and life: painting, architecture, cooking, and sex.

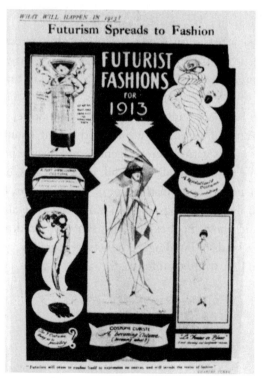

A journalistic commentary on "Futurist Fashions," *The Bystander*, London, January 1913

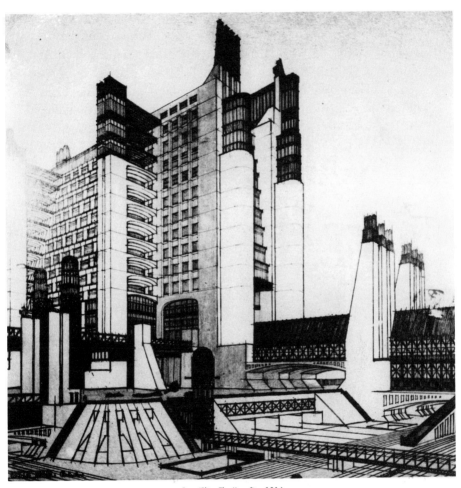

Sant 'Elia: *The New City*, 1914

The Dadaists also wanted to create work that would be different from traditional fine art—which they considered a meaningless and elitist pursuit. They wanted to annihilate previous notions about Art in order to revitalize culture. Dadaists began making their new Art in a nightclub in 1916 when a group of them began doing performances, reciting poetry, and playing music at the Cabaret Voltaire in Zurich.

There were many different Dada groups, projects, and exhibitions throughout the teens and twenties in Barcelona, Berlin, Bucharest, Cologne, New York, Paris, Prague, Warsaw, and Zurich.

Hugo Ball in costume reciting poetry at the Cabaret Voltaire, 1916

Among the most successful projects of the Dadaist avant-garde were the photomontages of John Heartfield. Heartfield, who joined the Communist party 1917, created one of the more visible critiques of fascism. He saw his work as an "art propaganda in the service of the working class movement." During the 1930s, Heartfield regularly contributed anti-Nazi, anti-fascist photomontages to *AIZ* (*Arbeiter-Illustrierte Zeitung*, or Workers Illustrated Weekly)—a weekly newspaper whose circulation was half a million.

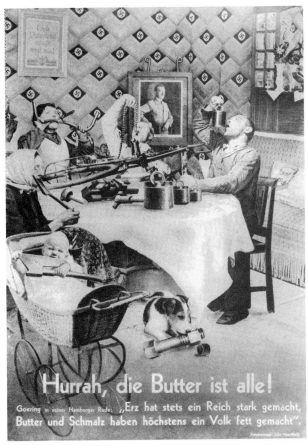

John Heartfield: "*Hurrah, the butter is all gone!*" *AIZ*, December 19, 1935 (a play on Goering's statement that "Iron has always made a country strong, butter and lard only make people fat")

Man Ray: *The Surrealist "Centrale,"* 1924 (*standing, left to right:* Jacques Baron, Raymond Queneau, André Breton, Jacques Boiffard, Giorgio De Chirico, Roger Vitrac, Paul Eluard, Philippe Soupault, Robert Desnos, Louis Aragon; *seated:* Pierre Naville, Simone Collinet-Breton, Max Morise, Marie-Louise Soupault)

The Surrealists also wanted an Art that would transform life. They did not believe that Art should be restricted to precious objects preserved in museums. Surrealism was not supposed to be a Miró painting hanging in a museum of modern Art; rather, it was supposed to be an active and dynamic means of living modern life. When Surrealism was first organized, the Surrealists were wary of considering contemporaneous fine art Surrealism. In his first manifesto of 1924, André Breton, the founder of Surrealism, called painting a "lamentable expedient."

Surrealism was a new way of living—of pursuing one's desire and "the marvelous" in life. Surrealism was wandering through the streets of Paris, looking for chance encounters. It was drifting from movie house to movie house to experience dreamlike fragments of different films. It was being hypnotized and holding seances—and it was also producing creations that would trigger a Surreal experience. To achieve this, Surrealists wrote poetry, made paintings and sculpture, took photographs, shot films, and published journals, magazines, and books.

232

Man Ray: *Waking Dream Seance*, 1924 (*standing, left to right:* Max Morise, Roger Vitrac, Jacques Boiffard, André Breton, Paul Eluard, Pierre Naville, Giorgio De Chirico, Philippe Soupault; *seated:* Simone Collinet-Breton, Robert Desnos, Jacques Baron)

Brassaï: *Nocturnal View from Notre Dame*, 1933

Brassaï: *Quai de Bercy, Paris*, 1932–33, published in the Surrealist journal *Minotaure* 7, 1935

Brassaï: *The Statue of Marshal Ney in the Fog*, 1932, published in the Surrealist journal *Minotaure* 6, 1935

The artists involved with the Bauhaus, the Soviet experiments, and De Stijl wanted to redesign the modern world.

This is the Bauhaus Building in Dessau, designed in 1925–26 by Walter Gropius, the founding director of the Bauhaus.

This is the office of Walter Gropius at the Bauhaus in Weimar, as it looked in 1923.

This lamp, which is seen on the previous page on Walter Gropius's desk, was designed by Karl Jucker and Wilhelm Wagenfeld at the Bauhaus in 1923. A copy of this design is now available at the Museum of Modern Art's Museum Store.

Pendel Aluminium. Rohre Messing blank vernickelt. Ketten Messing matt vernickelt
Bauhaus-Modelle.

Tafel 1704

5486  M.E.107h  1 Lp.
H. 100 cm
Kugel 20 cm
Opal überfangen

5487  M.E.107d  1 Lp.
H. 110 cm
Kugel 40 cm
Opal überfangen

5488  M.E.104b  1 Lp
H. 110 cm
Kugel 40 cm
Opal überfangen

5489  M.E.94 b  1 Lp.
H. 110 cm
Kugel 40 cm
halb opal überfangen
halb matt

5490  M.E.85b  1 Lp
H. 100 cm
D. 30 cm
Schmirr schwarz

These Bauhaus light fixtures, designed by Marianne Brandt and Hin Bredendieck, were mass-produced by German factories in the 1920s.

239

This is one of the rooms of the Cafe L'Aubette in Strasbourg, constructed in 1928–29 (and destroyed in 1940). This cinema/dance hall was designed by the De Stijl artist Theo Van Doesburg.

This is a professional woman's suit designed by Varvara
Stephanova in 1922.

The early decades of the twentieth century were the years when the mass media as we have come to know it was forming. The artists of the international avant-garde thought they would contribute to the new vehicles of culture which would reach all people: radio, film, picture magazines, sound recordings, exhibitions. They envisioned themselves creatively transforming the modern world through news media, publicity, popular culture, and advertisements.

Umbo: *The Reporter, Egon Erwin Kisch*, 1926

This is a billboard designed around 1922 by the Bauhaus-trained artist Herbert Bayer for the German magazine *Die Neue Linie*.

This is a 1923 beer advertisement designed by Aleksandr Rodchenko. The text was written by Vladimir Mayakovsky.

This is what the Soviet pavilion looked like at the famous Pressa Exhibition, the "International Exhibition of Newspaper and Book Publishing," held in Cologne in 1928. El Lissitzky oversaw this exhibition design, which celebrated the power of the Soviet press. The installation was composed of photomontages and sculpture like the Soviet Star, complete with six spinning globes, moving text, and electric lights.

But the international avant-garde's vision of the future did not come to pass. Artists did not become the leading creators of the mass media. Artists today are not directing radio and TV shows. They are not producing ad campaigns and blockbuster films. The production and reception of fine art remain, for the most part, within the frameworks of aesthetic institutions: galleries, museums, art schools, auction houses, art magazines, and art sections of newspapers. Although we live with many of the innovations created by the international avant-garde, the relation of today's artists to the mass media is quite different from what artists imagined during the first half of the twentieth century.

Marcel Breuer: *Armchair, Model B3*, 1927–28

One of the key features of the mass media is the creation of a public image—like that of Charlie Chaplin, one of the first public images created at the beginning of this century by a fledgling mass media. Chaplin, who began making films in 1914, was by 1921 an international star. Chaplin fascinated movie audiences everywhere—and he fascinated the international avant-garde.

Cover of magazine *kino-fot* no. 2 by Varvara Stephanova, 1922

Another powerful but very different type of public image was that of a man born within 100 hours of Chaplin—Adolf Hitler. This dictator made full use of the new technologies of mass persuasion. Even down to his uniform, Hitler's image was self-consciously constructed. His uniform was exceptional in that it was without insignia of rank—thus making it easier for his audiences to see their leader as an everyman. Hitler exploited the picture press, radio, film, and public spectacles as resources to build and secure his reign. And it is interesting that these first two most renowned public images are everymen with a black mustache, one an icon of comedy, the other of horrific tragedy.

Adolf Hitler in a film still from Leni Riefenstahl's *Triumph of the Will*, 1936

In 1940, Chaplin ridiculed Hitler in his film *The Great Dictator*.

Muntadas is an artist whose work often examines the power of the mass media. This is an image of his installation *The Press Conference Room* (1991), which examines the use and misuse of language and the mass media by political figures.

The piece consists of a spotlit podium with microphones. A "media carpet" composed of newspapers from the city where the piece is shown runs from the podium to the opposite wall, where a video monitor plays a silent tape of political figures from the past and present, such as Hitler and Margaret Thatcher, who are standing in front of microphones. There is a soundtrack (coming from speakers on the walls) composed of fragments of historical and contemporary speeches, including those of politicians associated with the city where the piece is shown, which eventually converge into noise.

During the 1930s and 1940s, there were a variety of fates for the international avant-garde. However, during World War II there developed the widespread phenomenon of governments using the new arts and technologies to produce propaganda. In Germany Hitler closed the Bauhaus, banned the avant-garde, and enforced a neoclassical propaganda machine. In Italy, the avant-garde was supported by Mussolini and even worked with him. In the Soviet Union, artistic innovations of the teens and twenties were redirected by Stalin to Socialist Realism. In the United States, government-sponsored poster competitions and exhibitions celebrated the war effort.

# Haussuchung im „Bauhaus Steglitz"

### Kommunistisches Material gefunden.

Auf Veranlassung der Dessauer Staatsanwaltschaft wurde gestern nachmittag eine größere Aktion im „Bauhaus Steglitz", dem früheren Dessauer Bauhaus, in der Birkbuschstraße in Steglitz durchgeführt. Von einem Aufgebot Schutz-

war jedoch verschwunden, und man vermutete, daß sie von der Bauhausleitung mit nach Berlin genommen worden waren. Die Dessauer Staatsanwaltschaft setzte sich jetzt mit der Berliner Polizei in Verbindung und bat um Durch-

Alle Anwesenden, die sich nicht ausweisen konnten, wurden zur Festellung ihrer Personalien ins Polizeipräsidium gebracht.

polizei und Hilfspolizisten wurde das Grundstück besetzt und systematisch durchsucht. Mehrere Kisten mit illegalen Druckschriften wurden beschlagnahmt. Die Aktion stand unter Leitung von Polizeimajor Schmahel.

Das „Bauhaus Dessau" war vor etwa Jahresfrist nach Berlin übergesiedelt. Damals waren bereits von der Dessauer Polizei zahlreiche verbotene Schriften beschlagnahmt worden. Ein Teil der von der Polizei versiegelten Kisten

suchung des Gebäudes. Das Bauhaus, das früher unter Leitung von Professor Gropius stand, der sich jetzt in Rußland aufhält, hat in einer leerstehenden Fabriketage in der Birkbuschstraße in Steglitz Quartier genommen. Der augenblickliche Leiter hat es aber vor wenigen Tagen vorgezogen, nach Paris überzusiedeln. Bei der gestrigen Haussuchung wurde zahlreiches illegales Propagandamaterial der KPD. gefunden und beschlagnahmt.

Police raid on Berlin Bauhaus, reported in *Berliner Lokal-Anzeiger*, December 4, 1933

This deployment of Art as propaganda led many artists to reject political messages and the use of technologies and the mass media in their work after the war. In the late 1940s and early 1950s, Abstract Expressionists like Jackson Pollock returned to what was seen as the purity and integrity of abstract painting. Other artists, like those in the Situationist International (1957–1972), continued the tradition of the pre-WW II avant-garde and deployed diverse mediums and anti-aesthetic practices. Different from the utopian avant-garde of the first half of the twentieth century, however, the S.I. took on postwar capitalism and the mass media and criticized the postwar "bureaucratic society of controlled consumption," what they called "The Society of the Spectacle."

Situationist International poster "Down with the Spectacular Commodity Society," 1968

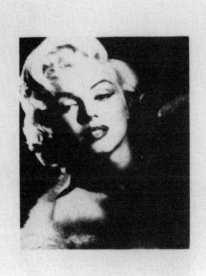

VI<sup>e</sup> CONGRES
DE L'INTER-
NATIONALE
SITUATION-
NISTE AN-
VERS DU 12
AU 15 NO-
VEMBRE 1962

ÉDITÉ PAR
INTERNATIONALE
SITUATIONNISTE
B.P. 75-06 PARIS

Poster for the Sixth Congress of the Situationist International, November 12–15, 1962

253

Yves Klein: *Anthropometry, ANT 97*, 1960

(*opposite*) Yves Klein: *Action-Spectacle*, March 9, 1960, Galerie Internationale d'Art
Contemporain, Paris, photograph by Harry Shunk

# 10

## Art and Culture Today

After World War II, the mythologies about modern Art, as well as artists' expectations concerning what fine art can accomplish, changed. Today the utopianism that thrived at the beginning of the century has disappeared. The avant-garde artists working during the first half of the century thought they could radically reform the modern world. Most artists of the postwar era, however, have a somewhat ironic relationship to their work.

For example, this is Yves Klein painting with human paintbrushes in 1960.

Postwar painting in the U.S.—specifically Abstract Expressionism—has been understood by art historians as "The Triumph of American Painting" (which is the title of the most famous book on the subject). Abstract Expressionism has been received as a climax to the history of modern Art, as something completely new and original. But it is actually the beginning of the recycling of previous styles that has come to characterize so much of postwar culture and contemporary Art—what is often referred to as "postmodernism." The style that followed Abstract Expressionism, what we now call Pop Art, was first known in many instances as Neo-Dada. This is not to say that postmodernism is merely a recycling of styles; rather, it involves a critical and historical relationship to the mythology of style, high modernism, and an autonomous field of Art and aesthetics. Nonetheless, it was not only in the United States that the idioms of modern Art began to be recycled after the war. These appropriations of modernist styles took place all over the world—for instance, in Argentina, Australia, Canada, and Japan.

This 1947 painting, *Ritmos Cromaticos II*, is by the Argentinian artist Alfredo Hlito.

This is a 1950 abstraction by the Australian painter Ralph Balson.

257

This is a 1962 performance titled *Painting with Feet* (which was also done in 1956) by Kazuo Shiraga of the Japanese group Gutai.

This is a 1951 painting titled *Work* (*Birds at Night*) by the Gutai artist Jiro Yoshihara.

Art since World War II has remained, for the most part, within the boundaries of the prescribed aesthetic systems: the galleries, the alternative spaces, the museums, the art magazines, the art histories, the auction houses. This is different from the first half of the century, when the dominant traditions—Dada, Surrealism, the Bauhaus, De Stijl, the Soviet groups—were experiments in dismantling the frameworks of Art and creating new institutions for artistic practice, training, dissemination, and reception.

In the postwar era—and this is particularly the case since the 1960s and 1970s—the systems of Art have become, in a sense, more powerful than the individual art objects. Before World War II, the various systems for presenting, preserving, and publicizing modern Art were, relatively speaking, fledgling. Since the 1950s these systems have strengthened and developed and are more powerful—some would say more interesting—than the Art itself. For example, people generally do not read art magazines or the popular press to unravel questions of aesthetics; they are more interested in the way an art object is integrated into the art apparatus and in the workings of the art world. Most individuals do not read about Art to discover how an artist resolved the composition of a particular painting; rather, they read articles to learn about skyrocketing or crashing auction prices, to find out who is running our museums, and to know why a collector is buying a particular kind of photography. Articles and essays today deal with topics like galleries gentrifying neighborhoods. Magazine picture stories feature an artist's newly designed loft. The great aesthetic debates focus on the newest legislation regarding funding for the arts or the censorship battles on Capitol Hill.

Most of the great and ambitious artists of our time do not limit themselves to the creation of discrete objects. Instead, they produce objects or projects or installations that interact with the systems of Art. These artists criticize or work with the power of the galleries, the museums, the publications, the patrons, and the marketplace. Their work is then not completely controlled by the vehicles for the reception and distribution of Art.

An artist who works in this fashion can be thought of as "the artist-producer."

El Lissitzky, *Self Portrait, The Constructor,* 1924

Andy Warhol at his installation of *Flowers*, 1965, Galerie Ileana Sonnabend, Paris, photograph by Harry Shunk

Artists such as Bayer, Breton, Exter, Gropius, Heartfield, Lissitzky, Stephanova, and Van Doesburg set a precedent as artist-producers in the first half of the twentieth century. In the postwar era, if an artist wants to do more than merely fuel the art apparatus, the most effective strategies usually involve working with the institutions of culture. The artist who most fully met this challenge and who is the paradigm of the artist-producer is Andy Warhol. Although he did not have the utopian agendas of his predecessors, Warhol nonetheless made visible the way the system works. For four decades, Warhol, by himself and in collaboration with others, produced drawings, paintings, photographs, sculpture, and exhibition installations. He designed graphics and advertisements, directed and produced movies, created happening-spectacles, managed a rock-and-roll band, published a magazine, acted in and modeled for commercials, and collected Art, design, and popular culture. Even after his death, Warhol had ensured the creation of a posthumous corporation, the Andy Warhol Foundation for the Visual Arts.

Andy Warhol—hired to promote a $2.00 do-it-yourself paper-dress kit—and Gerard Malanga stencil a paper dress worn by Nico in an Abraham & Straus department store in Brooklyn, November 9, 1966, photograph by Fred W. McDarrah

Film stills from Andy Warhol's *Kiss*, 1963

One important area of Warhol's diverse activities was film. Warhol's 1963 *Kiss* deconstructs both the Hollywood closeup and the act itself, as the film presents couples—gay, straight, interracial—kissing. The black-and-white, 58-minute film is composed of a series of several-minute film reels. Each reel features a different couple kissing.

Andy Warhol filming *Girls in Prison*, 1965, photograph by Billy Name

Joseph Beuys was an artist-producer who created what he believed was "social sculpture." Conjuring German Romantic symbology and a shamanistic public image, Beuys created objects, installations, projects, and performances that were collaborative, involved the systems of Art, and were often complete only with the audience. As an extension of his Art, Beuys founded what he called the Free International University for Creativity and Interdisciplinary Research, and he was one of the prominent members of the Green Party. Beuys, however, promoted his shamanistic role as well as somewhat simplistic utopian aesthetic strategies for the transformation of everyday life which were based upon an evolutionary model of history. Nonetheless, prior to his death in 1986, he exerted tremendous influence upon several generations of European artists, as he worked from the 1960s through the 1980s.

The most powerful legacy of Beuys is his influence as a teacher and his public image, which was ever so carefully constructed in documentary photographs. Everything about this artist—from his uniform attire (a felt hat, fishing vest with knife, jeans, and boots) to his "signature" materials (fat, felt, iron, tools, found objects, and industrial equipment)—evokes survival in a postwar, postindustrial, nuclear age.

(*opposite*) Joseph Beuys: *Spade with Two Handles*, 1965, photograh by Ute Klophaus

Han Haacke is a producer-artist who disrupts the smooth workings of the artworld by making visible what often remains unseen when viewing works of Art. He has specifically led the field in creative revelations regarding corporate sponsorship of the arts.

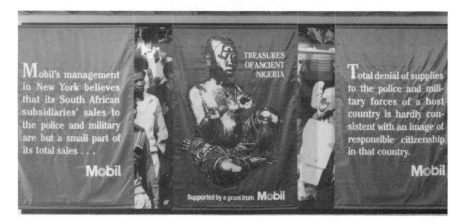

His *MetroMobiltan*, first shown in a New York gallery in 1983, is a miniature facade of Manhattan's Metropolitan Museum of Art. Haacke's version of blockbuster banners illustrates the "Treasures of Ancient Nigeria"—an exhibition funded by Mobil, which was one of the largest U.S. investors in South Africa when the piece was made. Haacke reprinted citations from Mobil's response to a shareholders' request to prohibit sales to South Africa: "denial of supplies to the police and military is not responsible citizenship." Behind this facade of banners is a photograph of a funeral procession for black victims shot by South African police in 1985. Haacke's installation makes visible the connections between this blockbuster exhibition that celebrates African culture and its sponsor's support of apartheid.

This artist has made it his business to lay ruin to a modernist faith in the autonomy of Art.

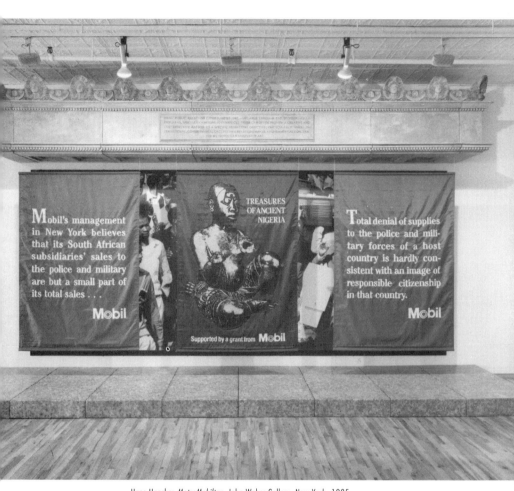

Hans Haacke: *MetroMobiltan*, John Weber Gallery, New York, 1985

*Peace Tower,* Los Angeles, 1965

Since World War II, some artists have continued to create projects that have side-stepped the prescribed frameworks of fine art in order to initiate social change. An early example of what would become an explosion of activist creativity in the late 1960s and early 1970s is the *Peace Tower* of 1965—a collaborative project by more than 400 artists. The *Peace Tower* was installed on an empty lot in Hollywood on the Sunset Strip. For three months, a fifty-foot steel tower and a billboard studded with four-foot-square creations donated by artists was one of the first protests against the U.S. involvement in the Vietnam War. The *Tower* drew crowds daily. It was covered by the international press and local TV. The *Tower* became a centerpiece for the social geography of the Los Angeles community and allowed for a creative street spectacle that addressed the issues of the day.

Group Material: *Democracy Project*: "Education and Democracy," the Dia Art Foundation, New York, 1988

Since 1980, the artists' collaborative Group Material has been producing projects for traditional and nontraditional public spaces such as museums, storefronts, alternative arts organizations, subway trains, billboards, and buses. Their projects make Art available to a broad public and examine such topics as American democracy, education, the mass media, U.S. intervention in Central and South America, and the AIDS crisis. Their art exhibitions include the work of scores of artists. They collaborate with community groups. They produce publications.

The above photograph is of the "Education and Democracy" installation, which was one of a series of exhibitions created by Group Material at the Dia Foundation in New York titled *Democracy*. (The other three installations dealt with "Politics and Election," "Cultural Participation," and "AIDS and Democracy: A Case Study.") In conjunction with the exhibition, Group Material held "Town Meetings," which brought diverse communities together for discussion, and as an extension of these activities they produced a book about Art, culture, and politics with essays by a spectrum of writers including Erma Bombeck, Henry Louis Gates, and Bill Moyers.

271

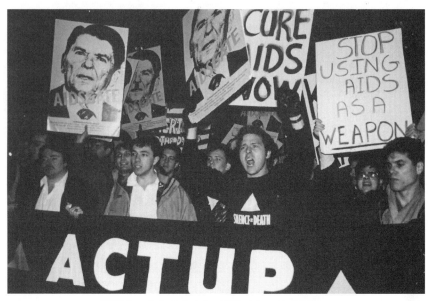

ACT-UP Demonstration in Manhattan, 1988, photograph by Rolf Sjogren

In the mid-1980s and early 1990s there was a resurgence of cultural activism. Among the most visible groups are ACT-UP (AIDS Coalition to Unleash Power), WHAM! (Women's Health Action and Mobilization), and WAC (Women's Action Coalition). ACT-UP, founded in 1989, was the first and most visible of these groups. Through its creative demonstrations, its products (buttons, decals, T-shirts), its watchdog activities, its art exhibits, and its videos, ACT-UP has become an important voice within the AIDS crisis. The coalition calls attention to the inequities that affect research and legal policy decisions. ACT-UP has fought for the rights of gays and lesbians who have been under attack during this health and civil liberties crisis.

In 1988 WHAM! was formed in response to the backlash against U.S. women and the Supreme Court's *Webster* decision, which chiseled away at a woman's freedom of choice. After the Anita Hill controversy, WAC was formed in 1992. All three coalitions have myriad affiliated committees and groups that deploy the spectrum of creative options for getting their messages out.

WAC demonstration during "St. John's Rape Trial" in Queens, New York, 1992, photograph by Meryl Levin

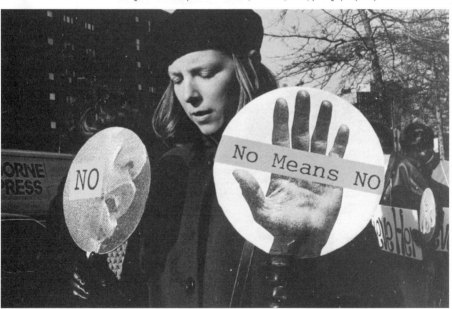

Stills from the 1991 pro-choice video *Access Denied*, which was created by ReproVision, a WHAM! video collective. The video is an attempt to educate viewers about women's healthcare issues and to encourage "more people to do clinic support and direct action around women's reproductive freedom."

*The Names Project Quilt*, Washington, D.C., 1987, photograph by Ellen B. Neipris

Like the activist projects, the AIDS quilt exemplifies powerful and meaningful creations that blur boundaries between Art and everyday life, Art and popular culture, the artworld and everybody else.

*The Names Project Quilt*, Washington, D.C., 1987, photograph by Ellen B. Neipris

Maya Lin: *Vietnam Veterans Memorial*, 1982, photograph by William Clark

Richard Serra: *Tilted Arc*, installed 1981, dismantled 1989

How do public Art and monuments affect the people who view them? In Richard Serra's site-specific Minimalist works he seeks to make visible the conditions of the social landscape. His *Tilted Arc*, a massive sheet of steel that obstructed an unsightly corporate plaza in front of a government administration building, was removed in 1989 after protests against the piece. Although *Tilted Arc* was destroyed, its installation, controversy, and destruction manifested issues of the plaza that were related to the piece's genesis and meaning.

For the *Vietnam Memorial*, Maya Lin appropriated the abstract, Minimalist idiom, which is commonly unintelligible to individuals unfamiliar with modern Art, and inflected it with a very personal and historically specific detail: the names of all the U.S. military personnel who died in the Vietnam War and all U.S. persons missing in action. This element of "the names" completed the piece's silent, tactile eloquence, creating both an aesthetic achievement and a monument easily read by its viewers as a war memorial—or an anti-war memorial.

Maya Lin: *Vietnam Veterans Memorial*, 1982, photograph by William Clark

What is the role of Art today, when so many of the agendas associated with modern Art, particularly those of the twentieth-century avant-garde, have been realized on the other side of the great divide—popular culture? Since World War II, rock-and-roll (which developed in the 1950s postmodernist culture) has shared much of the legacy of modern Art. Like the international avant-garde, rock-and-roll is the creative product of a rebellious youth culture trying to reach a mass audience. Its artists embrace technological innovation. Their lives and personal styles are often counterculture. Many rock groups have appropriated creative strategies of modern art history: Some stage acts can be seen as Neo-Dada performance, others have lifted ideas from the Surrealists, the Situationists, and other art groups. Although pop music has its individual stars like Elvis and Madonna, most rock musicians, like the international avant-garde, work collaboratively, in bands. But however much a rock-and-roll group may initially appeal to a specific youth subculture, its potential for vast global audiences is different from that of fine art, which re-mains within the arcane reaches of high culture.

The recordings of the most universally famous group, The Beatles, continue to permeate our social landscape twenty-five years after they disbanded. Their music is part of the soundtrack of our lives. Whether an original recording or muzak, we hear Beatles songs in stores, on streets, in elevators, and in the privacy of our bed-rooms—in India, New Zealand, California, and Norway. Similarly, the sounds and images of mainstream film, TV, and radio have become the universal languages of the modern world.

The Beatles

The Supremes

How should we evaluate the impact of Art compared to the power of popular culture? Can popular culture accommodate the radical critique that has been the domain of modern Art? In Cindy Sherman's early "film stills," for example, she challenged patriarchal conventions both in her pictures (by photographing herself masquerading as vaguely familiar feminine stereotypes) and in her method (by being both creator and subject, director and actress, producer and product). But isn't that one of the things that Madonna does in her productions? Surely there are important differences between the work of Sherman and that of Madonna. Nonetheless, Madonna also deals with our culture's feminine stereotypes. She plays with them, exploits them, challenges them—and she does it with pop music and videos that millions of people want to see and hear.

Cindy Sherman: Untitled film still, 1978

Lois Lane in the 1950s television program *Superman*

Cindy Sherman: Untitled film still, 1979

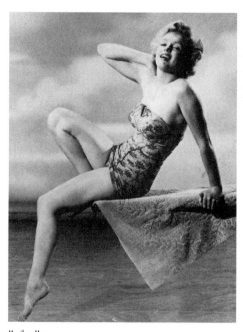

Marilyn Monroe

Madonna in a video still from
*Material Girl,* 1985

Marilyn Monroe in *Gentlemen Prefer Blondes,* 1953

Madonna in *Truth or Dare*, 1991          Liza Minnelli in *Cabaret*, 1972

Should we diminish the seductive "poetry" and the social critique of great rock music? Isn't one of the most trenchant and memorable statements on "desire" and consumer culture the Rolling Stones' hit "Satisfaction"? Isn't it time to leave behind criteria that equate "high" with Art and "low" with popular culture and commerce, considering the dominance of the market regarding the value of Art and the impact and eloquence of certain aspects of popular culture such as rap, World Beat, and the flood of pop and ethnic rock music that speak a language for both the masses and the margins?

The Rolling Stones

Public Enemy's rap music is among the most eloquent and powerful creations dealing with the issues of race in America. Unfortunately, some of the individuals affiliated with P.E. have, at times, shown discouraging intolerence to other groups, such as gays and Jews. Their work nonetheless continues the tradition of the important artists of the international avant-garde.

Public Enemy's music video "Shut 'em down," directed by Stephen Kroninger, Mark Pellington, and Lewis Klahr, is a manifesto for cultural revolution. Fast-paced graphics reminiscent of those of the Situationist International feature images of great African-American leaders, film footage of blacks being beaten in race riots, racist cartoons, and tabloid news clippings which are interspersed with the lyrics of "Shut 'em Down," as well as messages such as "seize the time," "the black side of American history," "freedom," "knowledge," "vision," "wisdom," "education," "strength," "action," "justice," and "power." Chuck D., P.E.'s leader, writer, MC, and designer, raps about "the battle for the mind." He speaks of the racism of the past—and the present. Very much in the spirit of artists like Hans Haacke who make visible the workings of power, Chuck D. calls his audience to action and empowerment and then specifically speaks of their relation to corporate America:

> I like Nike but wait a minute
> The neighborhood supports so put some
> Money in it
> Corporations owe
> Dey gotta give up the dough
> To da town
> Or Else
> We gotta shut 'em down

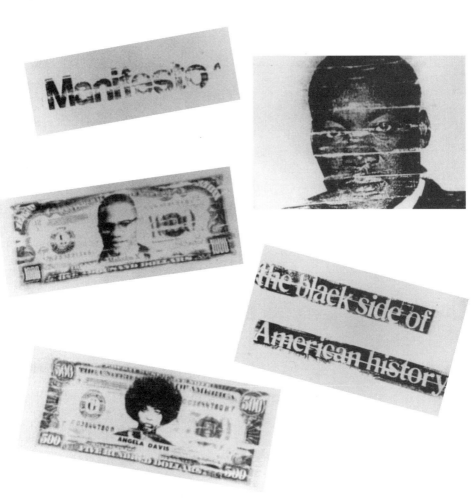

Video stills from Public Enemy's "Shut 'em down," a 1991 music video directed by
Stephen Kroninger, Mark Pellington, Lewis Klahr

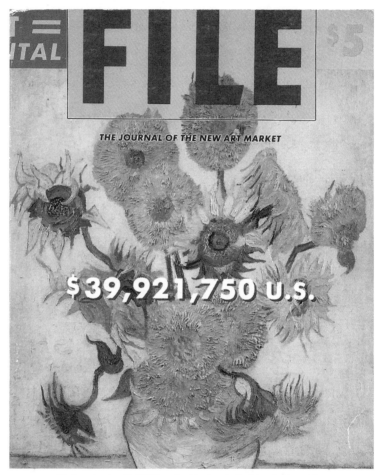

*File Megazine*, (no. 28, 1987), produced by the artists' collaborative General Idea

Fine art does not reach as many people as popular culture does. It remains a leisure-time activity for a relatively circumscribed population, and its status as high-yield investment often takes precedence over its other functions. How has the meaning of Van Gogh's *Sunflowers* been altered, now that it was bought at auction for $40 million?

To raise these issues is not to say that fine art is not powerful. Despite the parameters of culture today, Art retains tremendous importance and visibility in our society. Art is one especially powerful subculture that, at times, intersects or conjoins with popular culture. At its best, Art provides eloquence, beauty, and rigorous social critique.

The most important artists of our time are visionary in that they continue to challenge us to see our world differently. They represent our culture in enlightened and, at times, beautiful ways. Artists prepare the mind and the spirit for new ideas—new ways of seeing.

The key component of this 1989–90 installation titled *Cornered*, by the fair-skinned artist Adrian Piper, is a video in which she addresses her audience:

> I'm black. . . . If I don't tell you who I am, I have to pass for white. And why should I have to do that? . . . The problem is not simply my personal one, about my racial identity. It's also your problem, *if* you have a tendency to behave in a derogatory or insensitive manner toward blacks when you see none present. . . . Some researchers estimate that almost all purportedly white Americans have between 5% and 20% black ancestry. Now, this country's entrenched conventions classify a person as black if they have any black ancestry. So most purportedly white Americans are, in fact, black. . . . What are you going to do about it?

Although the artworld practices a certain amount of affirmative action, just go to any New York Art opening for evidence of the lack of integration within American communities. Piper uses her artwork to challenge viewers to look at the way we remain a racially divided society.

291

Krysztof Wodiczko brings what he calls our "dead monuments" to life by projecting images created by slide projections onto buildings and monuments. In his 1987 proposal for Union Square Park in New York City, he wanted to project images of homeless people onto the statues in the park. During the 1980s, as a result of the policies of Ronald Reagan and George Bush, the homeless became a national tragedy in the U.S. and filled its cities' streets. Wodiczko proposed this project because the homeless had been driven out of Union Square Park due to gentrification.

Wodiczko, who was born in Poland and has lived in Canada, moved to New York in the 1980s, when Manhattan skyscapers had become lit with dazzling light installations that delineated and gilded the "official" facade of the city during the Reagan era. In the homeless proposal—and in his realized projects—Wodiczko illuminates what might be called the "political unconscious" of our urban landscape.

(*opposite*) Krysztof Wodiczko: Proposal for *The Homeless Projection*, Union Square, New York, 1987 (allegory of Charity as homeless family, George Washington as homeless man in wheelchair with Windex, Lafayette as wounded symbol of freedom)

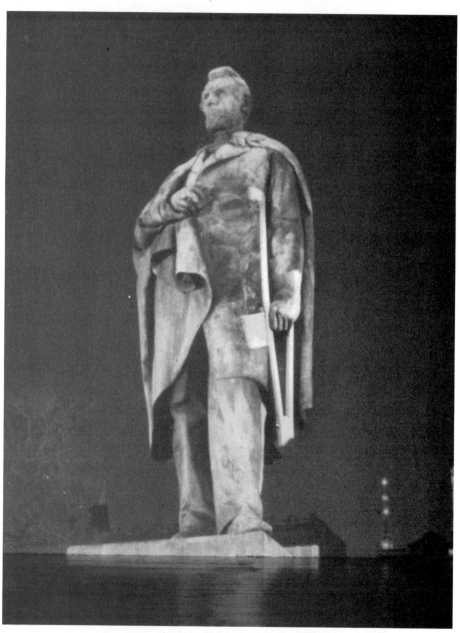

Krysztof Wodiczko: *Abraham Lincoln with Crutch*, 1987

Felix Gonzalez-Torres creates a diverse range of work that includes images, objects, installations, and billboards. Much of it can be seen as a meditation on mourning and the transience of life, as displayed by this 1991 paper piece, where hundreds of sheets of stacked paper of a theoretically infinite supply printed with a black-and-white photograph of the vast and deep sea are meant to be taken, one by one, by the stream of gallery visitors.

Felix Gonzalez-Torres, *Untitled*, 1991 (ideal height: 7 inches, offset print on paper, endless copies)

Marcel Broodthaers: *Miroir d' Epoque Regency,*
*Bruxelles,* 1973

This is a work of Art by the late Belgian artist Marcel
Broodthaers. It is one of the thirteen installations, held in different lo-
cations from 1968 to 1972, that comprise his imaginary museum, the
*Musée d'Art Moderne, Départment des Aigles* (Museum of Modern
Art, Eagles Department). For this installation, the "Section des fig-
ures" held in Dusseldorf in 1972, Broodthaers borrowed, from all
kinds of collections and museums, several hundred eagles: paintings,
sculpture, stuffed, an eagle-shaped helmet, an Eagle-brand type-
writer, a comic strip. The eagle is a symbol replete with mythology
and tradition, evoking authority, courage, strength, nationality. Each
of Broodthaers's eagles was labeled (in English, German, and French)
"This is not a work of art." Broodthaers played with the idea that mu-
seums and the artistic treasures preserved in them are institutions
shaped by history and social conventions, and as such they manifest
not only the magic and the myths of one's culture but the way mean-
ing and power is sustained.

Marcel Broodthaers: *Musée d'Art Moderne, Département des Aigles, Section des Figures*, Stadische Künsthalle, Dusseldorf, 1972

If we accept the fact that everything is shaped by culture, we then acknowledge that we create our reality. We therefore contribute to it and can change it. This is an empowering way of living and of seeing ourselves and the world.

Judy Chicago
The Dinner Party"

Marcel Broodthaers: *Musée d'Art Moderne, Département des Aigles, Section des Figures* (detail), 1972

193
Ceci n'est pas
un objet d'art

70
This is not a
work of art

210
Ceci n'est pas
un objet d'art

133
Ceci n'est pas
un objet d'art

231
This is not a
work of art

82
This is not a
work of art

68
This is not a
work of art

72
Ceci n'est pas
un objet d'art

194
Ceci n'est pas
un objet d'art

100
This is not a
work of art

242
Dies ist kein
kunstwerk

97
This is not a
work of art

191
Ceci n'est pas
un objet d'art

207
Ceci n'est pas
un objet d'art

233
This is not a
work of art

192
Ceci n'est pas
un objet d'art

67
This is not a
work of art

146
Ceci n'est pas
un objet d'art

72
Ceci n'est pas
objet d'art

116
Ceci n'est pas
un objet d'art

a.K.
Dies ist kein
kunstwerk

a.K.
Dies ist kein
kunstwerk

H.C.
Ceci n'est pas
un objet d'art

H.C.
Ceci n'est pas
un objet d'art

**193** Ceci n'est pas un objet d'art

**70** This is not a work of art

**210** Ceci n'est pas un objet d'art

**133** Ceci n'est pas un objet d'art

**231** This is not a work of art

**82** This is not a work of art

**68** This is not a work of art

**72** Ceci n'est pas un objet d'art

**194** Ceci n'est pas un objet d'art

**100** This is not a work of art

**242** Dies ist kein kunstwerk

**97** This is not a work of art

**191** Ceci n'est pas un objet d'art

**207** Ceci n'est pas un objet d'art

**233** This is not a work of art

**192** Ceci n'est pas un objet d'art

**67** This is not a work of art

**146** Ceci n'est pas un objet d'art

**72** Ceci n'est pas objet d'art

**116** Ceci n'est pas un objet d'art

**a.K.** Dies ist kein kunstwerk

**a.K.** Dies ist kein kunstwerk

**H.C.** Ceci n'est pas un objet d'art

**H.C.** Ceci n'est pas un objet d'art

301

# Selected Bibliography

The following texts were cited within Believing Is Seeing or were used as specific references (original publication dates, where available, are included in parentheses).

Baudrillard, Jean. "The Precession of Simulacra." In *Simulations*, translated by Paul Foss, Paul Patton, and Philip Beitchman. New York: Semio text(e), Inc., 1983. Also published in *After Modernism: Rethinking Representation*, edited by Brian Wallis and with a foreword by Marcia Tucker. New York: The New Museum of Contemporary Art; and Boston: David R. Godine, 1984.

————. *For a Critique of the Political Economy of the Sign.* Translated and with an introduction by Charles Levin. St. Louis, Missouri: Telos Press, 1981.

Berger, John, with Sven Blom Berg, Chris Fox, Michael Dibb, and Richard Hollis. *Ways of Seeing.* New York: The Viking Press, (1972) 1973.

*Blindman* no. 2 (May 1917).

Bourdieu, Pierre. *Distinction: A Social Critique of the Judgement of Taste.* Translated by Richard Nice. Cambridge, Massachusetts: Harvard University Press, (1979) 1984.

Bourdon, David. *Warhol.* New York: Harry N. Abrams, Inc., 1989.

Bürger, Peter. *Theory of the Avant-Garde.* Translated by Michael Shaw and with a foreword by Jochen Schulte-Sasse. Minneapolis: University of Minnesota Press, (1974) 1984.

Cabanne, Pierre. *Dialogues with Marcel Duchamp.* Translated by Ron Padgett. From the series *The Documents of 20th Century Art.* New York: The Viking Press, 1971.

Chipp, Herschel B., editor. *Theories of Modern Art: A Source Book by Artists and Critics.* Berkeley, Los Angeles, and London: University of California Press, 1970.

Clark, Kenneth. *Leonardo da Vinci: An Account of His Development as an Artist.* Middlesex, England: Penguin Books, (1939) 1975.

Clifford, James. *Predicament of Culture: Twentieth-Century Ethnography,*

*Literature, and Art.* Cambridge, Massachusetts, and London: Harvard University Press, 1989.

Collingwood, R. G. *The Principles of Art.* Oxford: Clarendon Press, (1938) 1964.

Condon, Patricia, with Marjorie B. Cohn and Agnes Mongan. *The Pursuit of Perfection: The Art of J. A. D. Ingres.* Edited by Debra Edelstein. Louisville: Speed Art Museum and Bloomington: Indiana University Press, 1983.

de la Croix, Horst, and Richard G. Tansey. *Gardner's Art Through the Ages: Eighth Edition.* New York: Harcourt Brace Jovanovich, Publishers, (1926) 1986.

Crimp, Douglas. "The End of Art and the Origin of the Museum." In *Art Journal* 46, no. 4 (Winter 1987), 261–266.

Debord, Guy. *Society of the Spectacle.* Detroit: Black & Red, (1967) 1983.

de Saussure, Ferdinand. *Course in General Linguistics.* Edited by Charles Bally and Albert Sechehaye with Albert Riedlinger, translated and annotated by Roy Harris. La Salle, Illinois: Open Court, (1916) 1983.

Evans, David. *John Heartfield AIZ: Arbeiter-Illustrated Zeitung, Volks Illustrierte, 1930–38.* Edited by Anna Lundgren. New York: Kent, 1992.

Ferguson, Russell et al. *Discources: Conversations in Postmodern Art and Culture.* Foreword by Marcia Tucker and photographic sketchbook by John Baldessari. New York: The New Museum of Contemporary Art; and Cambridge, Massachusetts and London: The MIT Press, 1990.

———. *Out There: Marginalization and Contemporary Cultures.* Foreword by Marcia Tucker and images selected by Felix Gonzalez-Torres. New York: The New Museum of Contemporary Art; and Cambridge, Massachusetts and London: The MIT Press, 1990.

Foucault, Michel. *The Order of Things: An Archaeology of the Human Sciences (Les Mots et les choses, 1966).* New York: Vintage Books, 1973.

———. *The Archaeology of Knowledge & the Discourse on Language.* Translated by A. M. Sheridan Smith. New York: Pantheon Books, (1971) 1972.

*Futurismi: Futurism & Futurisms.* Organized by Karl Gunnar Pontus Hulten, et al., and translated by Karen Winter Beatty Asterisco, et al. Venice: Palazzo Grassi; and New York: Abbeville Press, 1986.

General Idea. *File Megazine* 28, 1987.

Group Material, et. al. *Democracy: A Project by Group Material.* Edited by Brian Wallis. Seattle: Bay Press, 1990.

Greenberg, Clement. "Modernist Painting." In *The Collected Essays and Criticism: vol. 4, Modernism with a Vengeance, 1957–1969.* Edited by John O'Brian. Chicago and London: The University of Chicago

Press, 1993. Also published in the pamphlet *Forum Lectures*. Washington, D.C.: Voice of America, 1960; *Arts Yearbook* 4 (1961); *Art and Literature* no. 4 (Spring 1965); *The New Art: A Critical Anthology*, edited by Gregory Battock. New York: E. P. Dutton & Co., Inc., 1973; *Peinture-cahiers théoriques* no. 8–9 (1974) (titled "La peinture moderniste"); *Esthetics Contemporary*, edited by Richard Kostelanetz. Buffalo, New York: Prometheus Books, 1978; and *Modern Art and Modernism: A Critical Anthology*, edited by Francis Frascina and Charles Harrison. New York: Harper & Row, 1982.

Haskell, Francis. *Patrons and Painters: A Study in the Relations between Italian Art and Society in the Age of the Baroque*. Revised and enlarged edition. New Haven: Yale University Press, (1963) 1980.

Hudson, Kenneth. *A Social History of Museums*. Atlantic Highlands, New Jersey: Humanities Press, 1975.

Huyssen, Andreas. *After the Great Divide: Modernism, Mass Culture, Postmodernism*. Bloomington and Indianapolis: Indiana University Press, 1986.

Impey, Oliver, and Arthur MacGregor, editors. *The Origins of Museums: The Cabinet of Curiosities in Sixteenth- and Seventeenth-Century Europe*. Oxford: Clarendon Press, 1985.

Janson, H. W. *History of Art*. Fourth edition, revised and expanded by Anthony F. Janson. New York: Harry N. Abrams, Inc., and Englewood Cliffs, New Jersey: Prentice Hall, Inc., (1962) 1991.

———, with Dora Jane Janson. *History of Art: A Survey of the Major Visual Arts from the Dawn of History to the Present Day*. Englewood Cliffs, New Jersey: Prentice-Hall, Inc.; and New York: Harry N. Abrams, Inc., (1962) fifteenth printing, 1970.

Jauss, Hans Robert. "History of Art and Pragmatic History." In *Toward an Aesthetics of Reception*. Translated by Timothy Bahti and with an introduction by Paul de Man. Minneapolis: University of Minnesota, 1982. Also published in *New Perspectives in German Literary Criticism*, edited by Richard Amacher and Victor Lange. Princeton: Princeton University Press, 1979.

Kandinsky, Wassily. *Concerning the Spiritual in Art (Über das Geistige in der Kunst*, 1912). Translated and with an introduction by M. T. H. Sadler. New York: Dover Publications, Inc., 1977.

Kant, Immanuel. *The Critique of Judgment*. Translated and with an introduction by J. H. Bernard. New York: Hafner Press; and London: Collier MacMillan Publishers, 1951.

Kelly, Mary. *Post-Partum Document*. London: Routledge & Kegan Paul, 1983.

Kennedy, Duncan. "The Role of Law in Economic Thought: Essays on the Fetishism of Commodities." In *The American University Law Review* 34, no. 4 (Summer 1985), 939–1001.

————. "The Structure of Blackstone's Commentaries." In *Buffalo Law Review* 28 (1979), 205–382.

Krauss, Rosalind. "Grids." In *October* 6 (Summer 1979), 51–64.

————. "Re-presenting Picasso." In *Art in America* 68, no. 10 (December 1980), 90–96.

Kristeller, Paul Oskar. "The Modern System of the Arts." In *Renaissance Thought II*. New York: Harper Torchbooks, 1965. Also published in the *Journal of the History of Ideas* 21, no. 4 (1951), 496–527, and 23, no. 1 (1952), 17–46; and in *Ideas in Cultural Perspective*, edited by Philip P. Wiener and A. Noland. New Brunswick: Rutgers University Press, 1962.

Lacan, Jacques. *Ecrits: A Selection*. Translated by Alan Sheridan. New York and London: W. W. Norton & Company, (1966) 1977.

————. *Feminine Sexuality*. Edited by Juliet Mitchell and Jacqueline Rose, translated by Jacqueline Rose. New York and London: W. W. Norton & Company; and New York: Pantheon Books, 1982.

Lee, Rensselaer W. "Ut Pictura Poesis: The Humanistic Theory of Painting." In *The Art Bulletin* 21, no. 4 (December 1940), 167–269.

McLuhan, Marshall, and Quentin Fiore. *The Medium Is the Massage: An Inventory of Effects*. (Co-ordinated by Jerome Agel.) New York: Bantam Books, Inc., 1967.

McMahon, A. Philip. *Preface to An American Philosophy of Art*. Chicago: University of Chicago Press, 1945.

Malraux, André. "Museum without Walls." In *The Voices of Silence*, translated by Stuart Gilbert. Garden City, New York: Doubleday & Company, Inc., 1953, 13–128. Originally published as *Le Musée Imaginaire*, vol. I of *Psychologie de l'Art*. Paris: Albert Skira Editeur, 1947.

Mettam, Roger. *Power and Faction in Louis XIV's France*. New York: Basil Blackwell Ltd., 1988.

*Minotaure* 1–13. Paris: Editions Albert Skira, 1933–39. Also *Minotaure* 1–13, authorized reprint in four volumes. New York: Arno Press, 1968.

Morton, Frederic. "Chaplin, Hitler: Outsiders as Actors." In *The New York Times*, April 24, 1989, A-19.

Moskowitz, Anita Fiderer. *The Sculpture of Andrea and Nino Pisano*. Cambridge: Cambridge University Press, 1986.

Nochlin, Linda. "Why Have There Been No Great Women Artists?" In *Art and Sexual Politics*, edited by Thomas B. Hess and Elizabeth C. Baker. New York: Collier Books; and London: Collier MacMillan Publishers, 1973, 1–39. A shortened version of this essay was published in *Woman in Sexist Society: Studies in Power and Powerlessness*. Edited by Vivian Gornick and Barbara K. Moran. New York: Basic Books, 1971.

*Oxford English Dictionary*, vol. 1. Second edition, prepared by J. A. Simpson and E. S. C. Weiner. Oxford: Clarendon Press, (1933) 1989.

Pevsner, Nikolaus. *Academies of Art: Past and Present*. New York: DaCapo, (1940) 1973.

———. *A History of Building Types*. Princeton: Princeton University Press, 1976.

Plato. *The Being and the Beautiful: Plato's Theaetetus, Sophist, and States-man*. Translated and with a commentary by Seth Benardete. Chicago and London: The University of Chicago Press, 1984.

Potts, Alex. "Winckelmann's Construction of History." In *Art History* 5, no. 4 (December 1982), 377–407.

Praz, Mario. *An Illustrated History of Interior Decoration: From Pompeii to Art Nouveau*. London: Thames and Hudson, (1964) 1981.

Reich, Charles A. "The New Property." In *The Yale Law Journal* 73, no. 5 (April 1964), 733–781.

Richter, Hans. *Dada Art and Anti-Art*. London: Thames and Hudson, 1965.

Ross, Andrew. *No Respect: Intellectuals & Popular Culture*. New York and London: Routledge, 1989.

Rubin, William Stanley. *Picasso and Braque: Pioneering Cubism*. New York: The Museum of Modern Art, 1989.

Sandler, Irving. *The Triumph of American Painting: A History of Abstract Expressionism*. New York: Harper & Row, Publishers, 1970.

Seling, Helmut. "The Genesis of the Museum." In *The Architectural Review* 141, no. 840 (February 1967), 103–114.

Staniszewski, Mary Anne. "Capital Pictures." In *Post-Pop Art*, edited by Paul Taylor. Cambridge, Massachusetts: The MIT Press and Flash Art Books, 1989, 159–170. Another version of this essay was published in *File Magazine* 28 (1987), 13–25.

———. "City Lights." In *Manhattan, inc.* 4, no. 4 (March 1987), 151–58.

———. "Conceptual Art." In *Flash Art* 143 (November 1988), 88–97.

———. "The New Activism." In *Shift* 5 vol. 3, no. 1 (1988), 7–11.

———. "For What It's Worth: Canonical Texts." In *Arts Magazine* 65, no. 1 (September 1990), 13–14.

———. "For What It's Worth: Party Politics at the Metropolitan Museum." In *Arts Magazine* 64, no. 8 (April 1990), 13–14.

Stella, Frank, and Donald Judd. Radio Interview with Bruce Glaser, broadcast on WBAI-FM, February 1964, in program "New Nihilism or New Art?" which also included Dan Flavin. Published as "Questions to Stella and Judd," edited by Lucy R. Lippard and supplemented with additional statements by Stella and Judd of December 1965, in *Art News* 65, no. 5 (September 1966), 55–61; and reprinted in *Minimal Art: A Critical Anthology*, edited by Gregory Battock. New York: E.P. Dutton & Co., Inc., 1968.

Sutton, Peter, et. al. *Dreamings: The Art of Aboriginal Australia*. New York: The Asia Society Galleries in association with George Braziller Publishers, 1988.

Talley, Mansfield Kirby Jr. "The 1985 Rehang of the Old Masters at the Allen Memorial Art Museum, Oberlin, Ohio." In *The International Journal of Museum Management and Curatorship* 6, no. 3 (September 1987), 229–252.

Taylor, Paul. "Primitive Dreams Are Hitting the Big Time." In *The New York Times*, May 21, 1989, sec. II, 31 and 35.

Trachtenberg, Marvin. *The Campanile of Florence Cathedral: "Giotto's Tower."* New York: New York University Press, 1971.

Tisdall, Caroline. *Joseph Beuys*. New York: The Solomon R. Guggenheim Museum, 1979.

Tournepiche, Jean-Francois. "The Living Museum: Faux Lascaux." In *Natural History* 102, no. 4 (April 1993), 72.

Vandevelde, Kenneth J. "The New Property of the Nineteenth Century: The Development of the Modern Concept of Property." In *Buffalo Law Review* 29, no. 1 (Winter 1980), 325–67.

Vasari, Giorgio. *The Lives of the Most Eminent Painters, Sculptors & Architects*. Translated by Gaston Du C. de Vere. Reprint in ten volumes of 1912–14 edition, a translation of the revised second edition (1568) (first edition, 1550). New York: AMS Press, 1976.

von Holst, Niels. *Creators, Collectors and Connoisseurs: The Anatomy of Artistic Taste from Antiquity to the Present Day*. New York: G. P. Putnam's Sons, 1967.

Walton, Guy. *Louis XIV's Versailles*. Chicago: University of Chicago Press; and Middlesex, England: Penguin Books, 1986.

Williams, Raymond. *Culture and Society: 1780–1950*. New York: Columbia University Press, (1958) 1983.

Winckelmann, Johann Joachim. *History of Ancient Art (Geschichte der Kunst des Alterthums, 1764)*. New York: F. Ungar Publishing Company, 1969.

# Picture Credits